IMAGES
of America

SEATTLE'S BELLTOWN

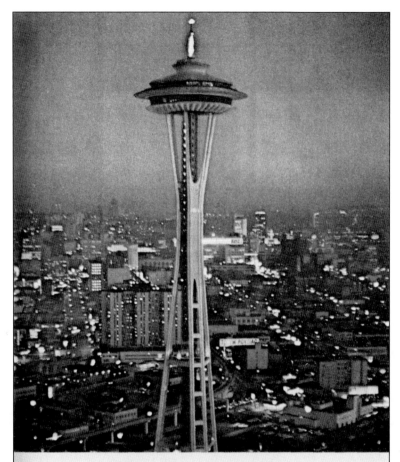

The Space Needle
for dining that's out of this world.

Minus 40 seconds and counting. A galaxy-gold capsule elevator waits to whisk you skyward along the outside of the Space Needle—at a breath-taking rate of 800 feet per minute. Destination: the Space Needle's revolving restaurant, high atop Seattle, and famous for its delectable dining and panoramic viewing.

At the Space Needle, lunch, dinner and Sunday brunch are exciting events. You may choose from an outstanding cuisine, sip the driest of cocktails, and watch the dazzling vistas of Seattle unfold as the restaurant revolves, almost imperceptibly, a full 360° each hour. Come up and see us soon. And bring the family. The Space Needle's like no other place on earth!

Reservations: 682-5656
Restaurant open 11:30 a.m. - midnight
Sunday, 9 a.m. - 9 p.m.
Observation Deck 9 a.m. - midnight—
7 days a week
Operated by the
Pentagram Corporation
in association with
WESTERN INTERNATIONAL HOTELS

Long before neo-pagans and goth rockers rediscovered the term, the Space Needle was conceived, built, and owned by the Pentagram Corporation (a five-man partnership that was later succeeded by the Space Needle Corporation). The 600-foot structure at Belltown's northern boundary was built for the 1962 world's fair and has been Seattle's predominant symbol ever since. It is shown here overlooking Belltown, an area frequently overlooked at the time of this advertisement. (Sunny Speidel; from *Seattle Guide* magazine.)

ON THE COVER: James A. Wehn's statue of Chief Seattle at Tilikum Place (see page 34) is draped in an American flag as Myrtle Loughery, the chief's great-great granddaughter, prepares to unveil it on Founders' Day, November 13, 1912. (Seattle Municipal Archives.)

IMAGES
of America

SEATTLE'S
BELLTOWN

Clark Humphrey

ARCADIA
PUBLISHING

Published by Arcadia Publishing
Charleston SC, Chicago IL, Portsmouth NH, San Francisco CA

Printed in the United States of America

Library of Congress Catalog Card Number: 2007930838

For all general information contact Arcadia Publishing at:
Telephone 843-853-2070
Fax 843-853-0044
E-mail sales@arcadiapublishing.com
For customer service and orders:
Toll-Free 1-888-313-2665

Visit us on the Internet at www.arcadiapublishing.com

*To the Belltown Bohemians past, present, and (God willing) future;
particularly Patricia Ryan (1944–2001) and Homer Spence (1941–1991)*

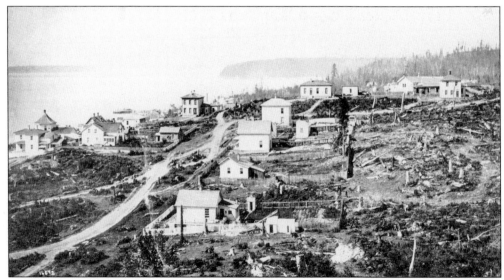

This is one of the earliest known photographs of "Bell Town, Washington Territory" in 1882, seven years before the territory became a state. Carleton E. Watkins, an employee of Asahel Curtis, one of the Northwest's pioneering photographers, took it. (Seattle Public Library, Seattle Room, No. 15191.)

CONTENTS

ACKNOWLEDGMENTS

This text is based partly on the research of Nick Bauroth, who wrote much about Belltown's origins for the old *Regrade Dispatch* newspaper before he left to pursue an academic career. He is now at North Dakota State University at Fargo.

Many of the same people who helped create my last book, *Vanishing Seattle*, also helped develop *Seattle's Belltown*. They include Julie Albright (my ever-diligent editor at Arcadia Publishing), Carolyn Marr (Museum of History and Industry), Nicolette Bromberg (University of Washington Special Collections), Jodee Fenton (Seattle Public Library, Seattle Room), Jeff Ware (Seattle Municipal Archives), and Walt Crowley and Marie McCaffrey (HistoryLink.org).

Several private collectors, including Elaine Bonow, Cam Garrett, Deran Ludd, Joe Mabel, Louie Roeffler, and Ashleigh Talbot, shared their stories and lore as well as their images.

The *Belltown Messenger* newspaper's team of contributors, including Gillian G. Gaar, Ronald Holden, Megan Lee, and publisher Alex R. Mayer, furnished more background tales. A *Messenger* interview with real estate agent Tom Graff was particularly helpful.

These image sources will be credited as follows: Museum of History and Industry (MOHAI); University of Washington Special Collections (UWSC).

INTRODUCTION

Some things take a while, like the Belltown boom. A century ago, civic boosters promised that Belltown, incorporating the flattened Denny Hill District to the east, would soon become a jewel of an urban neighborhood, glistening with fabulous shops and sophisticated residences. It took about eight decades for that destiny to fully transpire. That was a little late for the original boosters, but not for the descendants of area landowners who held on during the lean years.

Nowadays, big-name celebrities show up at Belltown's fashionable restaurants and bars. A few of them have had homes here, such as *South Park* cocreator Trey Parker, along with a few thousand business leaders, high-tech wizards, and retired ex-suburbanites.

Belltown is also home to artists and musicians (even though they're not as prominent here as they were in the 1980s), merchants, students, office workers, aging longshoremen, street people of various types, and lots of dogs (but very few young children). Belltown has become Seattle's busiest, liveliest, and most densely populated neighborhood.

But what is "Belltown" really? The name originally referred to a small strip of land, about a half-mile long and 500 feet wide, nestled between the waterfront bluff and Denny Hill's western slope. Some modern-day sticklers still adhere to this strict definition. The City of Seattle's official Belltown neighborhood boundaries are somewhat larger, essentially from Stewart Street to Denny Way and from Elliott to Fifth Avenues (with a few doglegs).

As editor of the monthly *Belltown Messenger* newspaper, this author holds a broader view. As a place of interlocking business and personal connections, Belltown's story necessarily involves its immediately adjacent districts. Clockwise from the north, those are Seattle Center, the Denny Triangle, the downtown retail district (including the Pike Place Market), and the waterfront. (A word to the literal, because the downtown and Belltown street grid was plotted parallel to the Elliott Bay waterfront, references to "north" and "south" in Belltown jargon, and in this book, really mean northwest and southeast.)

Apologies go out to those whose own favorite memories or places were left out due to space reasons. Unfortunately, not every apartment house, restaurant, bar, employer, building, or colorful resident greater Belltown has ever had could be included. Even within the smallest definition of Belltown's boundaries, there has been a lot of history here.

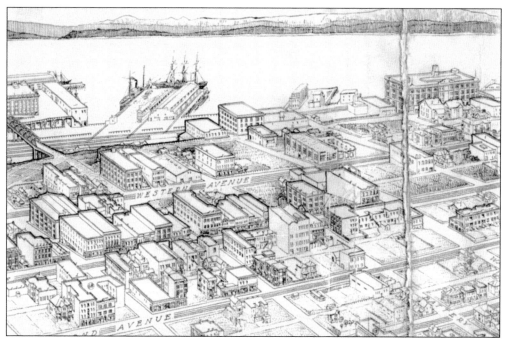

This is a detail from *A Map of Seattle's New Retail and Apartment-House District,* published by J. Dudley Stuart in 1917. Of the scattered buildings shown in the drawing, several are still standing, and several others were still standing as late as the 1980s and 1990s. Note the many still-empty plots east of Second Avenue and the holdout homeowner's property on a spite mound on Second Avenue south of Bell Street. (Seattle Public Library, Seattle Room.)

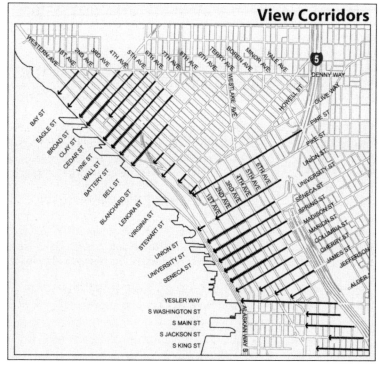

This more recent map depicts greater downtown Seattle's view corridor of streets. The Belltown/Denny Regrade District, as defined by the City of Seattle, is between the waterfront, Stewart Street, Fifth Avenue, and Denny Way. The adjacent Denny Triangle is bounded by Fifth Avenue, Denny Way, and Westlake Avenue. (City of Seattle.)

One

PIONEER BELLTOWN

The Illinois-born William Nathaniel Bell (1817–1887) and his wife Sarah Ann (1815–1856) were in Portland where they met fellow Midwesterners Arthur and David Denny, who were planning to strike out with their own colony farther north. The Bells became members of the Denny party, the 12 adults and 12 children who founded Seattle when they landed from the schooner *Exact* on November 13, 1851, at New York-Alki ("New York, By and By" in Chinook jargon), at what is now West Seattle's Alki Point. The following February, they resettled in a protected deepwater harbor at the site of today's Pioneer Square.

Just days after that, the Bells staked a 340-acre land claim more than a mile northwest of that site. The heart of "Bell's Town" was a narrow strip of relatively flat land bordered on the east and south by what became known as Denny Hill, and on the west by a tall bluff above the Elliott Bay waterfront. On this claim, William built a log cabin where his son Austin became the second Caucasian boy born in Seattle. That home was succeeded later by a frame house built of timber from Henry Yesler's sawmill (Seattle's first industrial enterprise).

As tensions between whites and natives grew in January 1856, the Bells (including a very ill Sarah Ann) left their land claim to huddle with the other Caucasian settlers inside Fort Decatur. During the resulting one-day Battle of Seattle, the second Bell home was burned. The Bells, their three daughters (three others had died in childhood), and their son left for California soon after. William returned to Seattle in 1870 as a widower to manage his now-valuable local landholdings.

In addition to Bell Street and Belltown, William's family is memorialized in Virginia Street and Olive Way (named for two of his daughters) and Stewart Street (named for Olive Bell's husband Joseph Stewart).

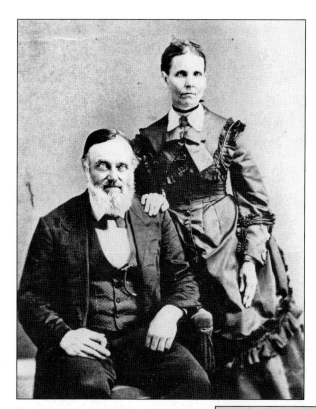

William N. Bell and his second wife, Lucy, are photographed in Seattle around 1880. William briefly returned to Illinois in 1872 to woo and wed Lucy, the sister of his deceased first wife, Sarah Ann. (MOHAI, No. SHS2515.)

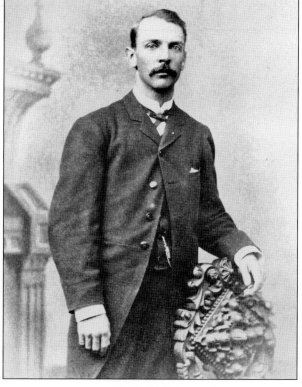

William Bell's son Austin Augustus Bell (1854–1889) inherited his father's land holdings and other assets. He was obsessed with something called "brain fever" (probably the disease now known as encephalitis), which he believed had killed his father, when Austin shot himself at age 35. (MOHAI, No. SHS3770.)

Princess Angeline (*c.* 1820–1896), born under the name Kikisoblu, was the daughter of Chief Seattle (alternately spelled "Sealth"), the native leader for whom the first white settlers named their town. She received her own English name from Catherine Maynard, a member of the Denny party. Angeline became a laundress for Seattle residents, living in a shack on Western Avenue near the waterfront. (UWSC, No. NA895.)

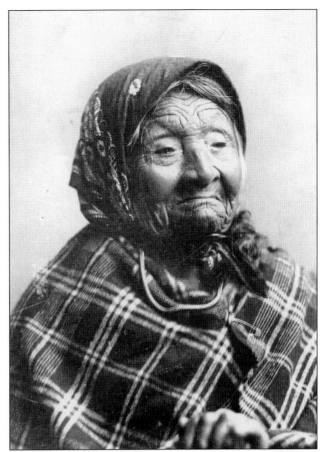

When the downtown business district burned in the great Seattle fire of June 6, 1889, the only hotel left standing in the city was William Bell's Bellevue Hotel at the southeast corner of First Avenue and Battery Street. Some local wags had called it "Bell's Folly," thinking nothing that far from downtown could attract enough guests. After the fire, the Bellevue was fully booked for more than three months. (UWSC, Wilse 102C.)

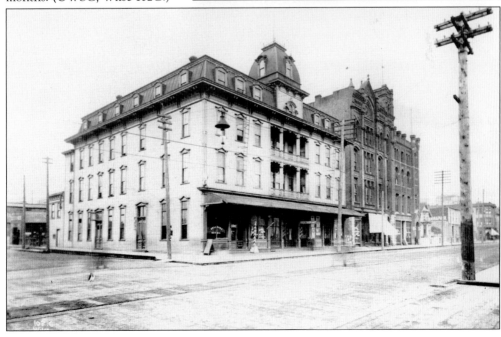

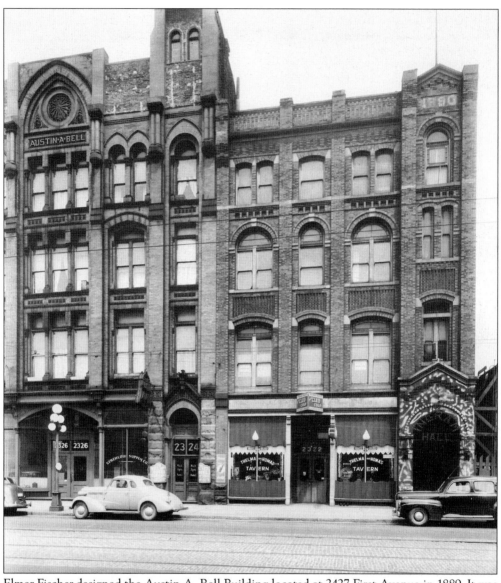

Elmer Fischer designed the Austin A. Bell Building located at 2427 First Avenue in 1889. It was commissioned by Austin Bell's widow Eve. During the 1897 gold rush days, the Bell Building served as a hotel and dance hall. By 1937, it became part of local building collector Sam Israel's stock of low-rent, low-maintenance budget properties. Israel left its three upper floors vacant rather than spend money to bring them up to code. The building gained landmark designation in 1977. Five years later, a fire seriously damaged what was left of its interior. In 1997, condominium developers bought the building from Israel's estate for $1 million. They kept the facade and constructed a modern structure behind it. The shorter building on the right was built in 1888 as an Odd Fellows temple; it later housed the Sterling Sleeping Bag factory. (MOHAI, No. 1983.10.13528.)

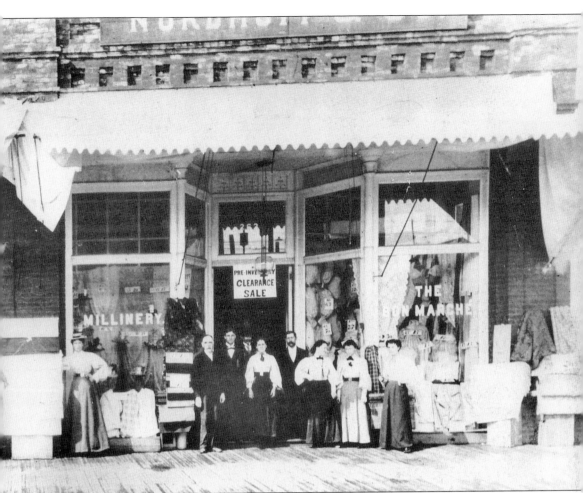

In 1890, new arrivals Josephine and Edward Nordhoff could not start a new clothing and dry-goods store downtown because of a shortage of available buildings following the 1889 fire. Thus the Bon Marché (named for Edward Nordhoff's favorite Paris store) opened in a modest building at First Avenue and Cedar Street in the original Belltown. The Bon Marché finally moved downtown in 1896 to Second Avenue and Pike Street; it relocated again to Fourth Avenue and Pine Street in 1929. It became the region's top department-store chain, with some 50 locations in five states, until its 2005 acquisition by Macy's. The Cedar Street building survived until the mid-1980s. (UWSC, Seattle Collection, No. UW2112.)

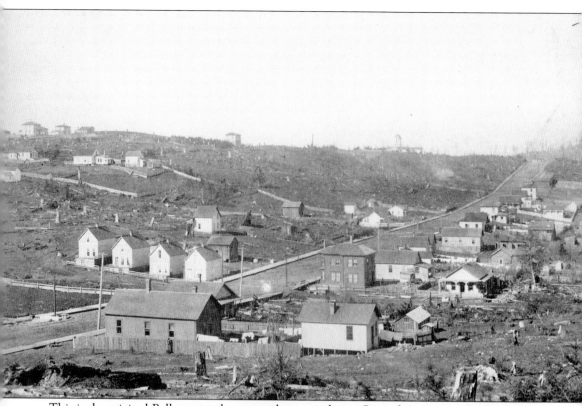

This is the original Belltown settlement with a meandering Second Avenue in the foreground. To get to Belltown from downtown in 1871, pedestrians had to cross a ravine on a fallen log. A boardwalk was built in 1875 from Pike Street to Bell Street. Elaine Bonow wrote in 1990, "On Sundays in 1876, it was the fashionable thing to promenade up Front Street [later First Avenue] to Bell's house on this wooden boardwalk." By 1880, a two-horse wagon regularly carried passengers and freight along this route. (MOHAI, No. SHS11438.)

Two

DENNY HILL
AND THE REGRADE

William Bell's land claim was adjacent to the hillside claim of the brothers Arthur and David Denny. Arthur Denny wanted the new State of Washington's capitol moved from Olympia to Denny Hill. When that didn't happen, Denny started planning his large namesake hotel, which would peer down regally over the downtown below.

R. H. Thomson didn't care for that view. The Scottish/Irish city engineer believed Seattle had a manifest destiny to grow to the north. Thomson also believed, as Walt Crowley had written, in "straight and level roads and boulevards." He had seen hydraulic mining in California and proposed Denny Hill be sluiced into Elliott Bay. Arthur Denny initially held out; so did developer James Moore, who bought and finally opened Denny's hotel.

While Moore and other Denny Hill landholders demurred, Thomson went to work removing the hill's edges. The regrade's plans specified a uniform grade not to exceed a 5-foot rise every 100 feet for easier travel by horse-drawn wagons.

As the last of western Denny Hill fell, the city's municipal plans commission hired Virgil Bogue to design a civic center in the newly flattened land that would kick-start the regrade's development. Bogue's plan proposed to remake the regrade and Seattle in the image of the "Civic Idea . . . a consciousness demanding the recognition of organic unity and intelligent system."

Bogue's vision, like Denny's, would go unfulfilled.

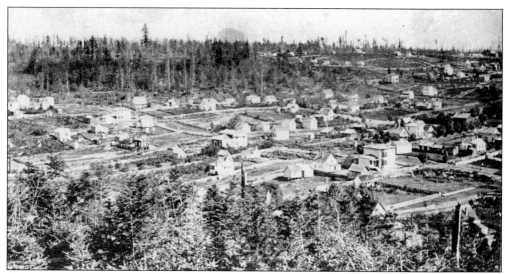

The north side and peak of Denny Hill are developed (well, as developed as that area got) in this 1896 image looking south from Queen Anne Hill. Besides the modest homesteads seen here, the hill sported a school, several churches, and some mom-and-pop groceries. (Seattle Public Library, Seattle Room.)

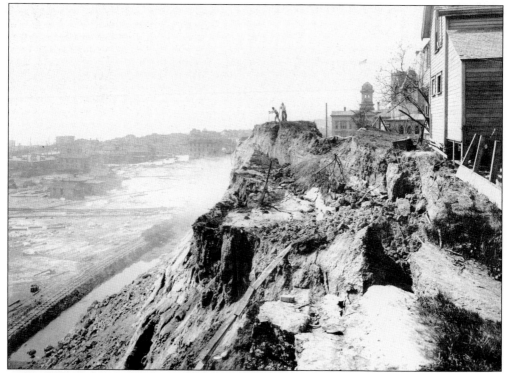

Denny School (the building to the right with the cupola and flagpole) opened in 1884 near Fifth Avenue and Battery Street and had 722 students by 1890. It survived the first phase of the regrade, as seen here, but closed for good in 1928. Belltown hasn't had a public school since. Community leaders now want to rectify this, so today's young condominium residents won't move away once they have kids. (MOHAI, No. SHS876)

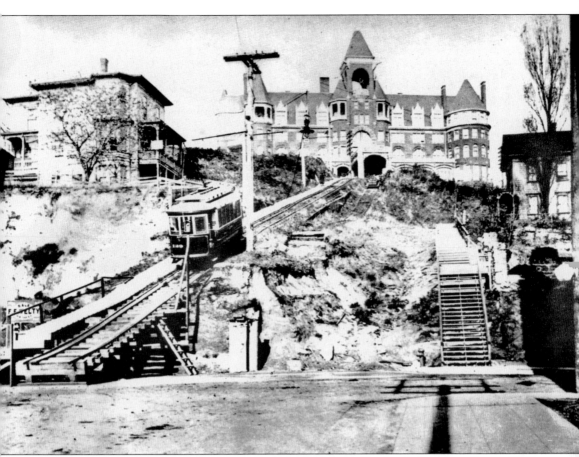

Arthur Denny built the eponymous Denny Hotel on part of his land claim atop Denny Hill's south bluff. But the Panic of 1893, a national economic depression, thwarted his dreams. The sprawling, ornate building stood empty, overlooking the north end of downtown, for a decade. Developer James A. Moore bought the place in 1903 and renamed it the Washington Hotel. It opened with a state visit by Theodore Roosevelt, for which the building was fully draped in bombastic bunting. Moore commissioned a one-block trolley line to connect the hotel with downtown. The Washington Hotel didn't stay open long. Within three years, Moore agreed to let the land be regraded. (UWSC, No. UW4696.)

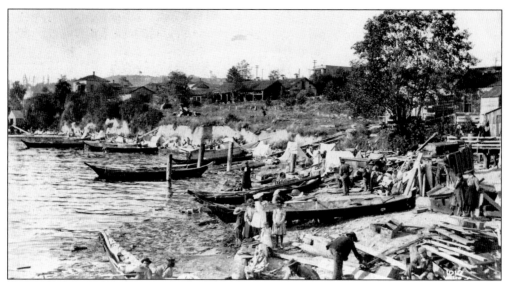

In the late 19th century, area natives maintained a summer camping place, Muck-Muck-Wum, on the waterfront at the foot of Bell Street, seen here in 1898. During the first regrade, this became the output end of a giant wooden flume that took Denny Hill dirt into the bay. (UWSC, No. NA698.)

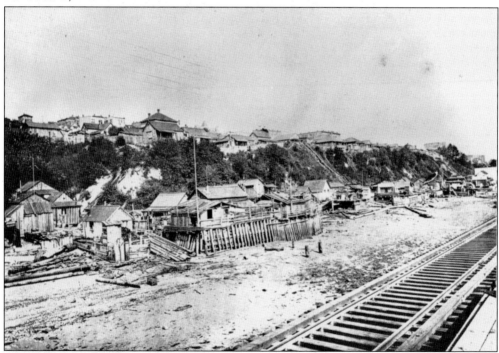

This shantytown was huddled against the waterfront bluff. The December 23, 1900, *Seattle Post-Intelligencer* reported on a small landslide that wrecked one cabin: "Shantytown is thickly built up with little cabins and is one of the most squalid districts of the city. The owners of the cabins are nearly all 'squatters' paying no rent, and it is therefore not probable that the city, or the railway companies which own most of the land, will take any action to prevent the recurrence of the landslide." (MOHAI, No. SHS-13091.)

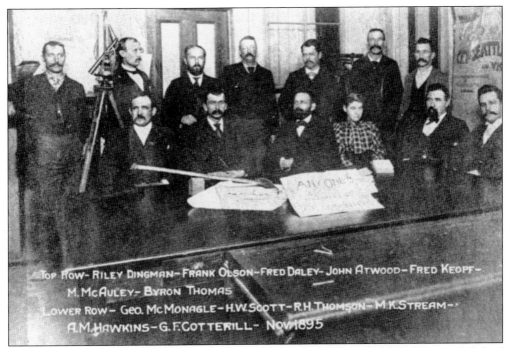

Top Row- Riley Dingman- Frank Olson- Fred Daley- John Atwood- Fred Keopf-
M. McAuley- Byron Thomas
Lower Row- Geo. McMonagle- H.W. Scott- R.H. Thomson- M.K. Stream-
A.M. Hawkins- G.F. Cotterill- Nov. 1895

Reginald Heber Thomson (1856–1949), third from left in the first row, was the regrade's chief promoter. As Seattle's city engineer off and on from 1892 to 1931, he also straightened and dredged waterways; reclaimed tide flats; built sewers, sidewalks, tunnels, and bridges; and paved roads. He was instrumental in creating the Cedar River watershed, City Light, the Port of Seattle, and the Hiram M. Chittenden Locks. (Seattle Municipal Archives.)

After three years in operation, the Washington Hotel came down—before the land beneath it came down. Judge Thomas Burke, a guest at its closing party, said, "It's a matter of the greatest regret that the Washington Hotel is to be taken down, and what used to be known as Denny Hill is to be leveled. . . . From a commercial point of view and certainly from an aesthetic one, it would have been much better to have saved Denny Hill." (UWSC, No. CUR477.)

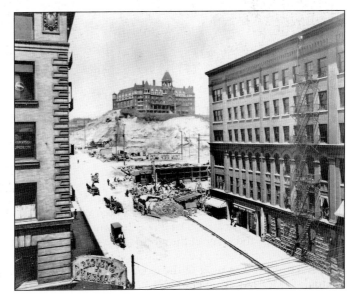

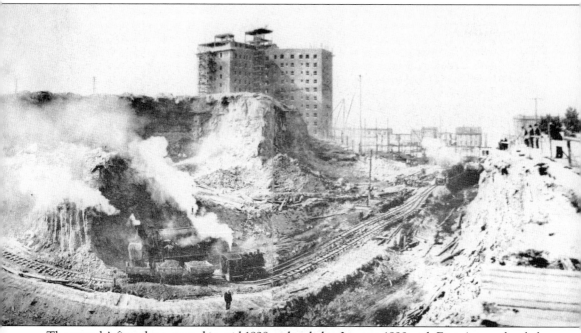

The regrade's first phase started in mid-1898 and ended in January 1899 with First Avenue leveled from Pine Street north to Denny Way. Contracts for the regrade's second and biggest phase, from Second to Fifth Avenues and from Pike to Cedar Streets, were issued in August 1903. This phase would take eight years to complete. In all, the city claimed, the various regrades removed some 4,354,625 cubic yards of earth. Street levels were lowered by as much as 110 feet. (Seattle Public Library, Seattle Room.)

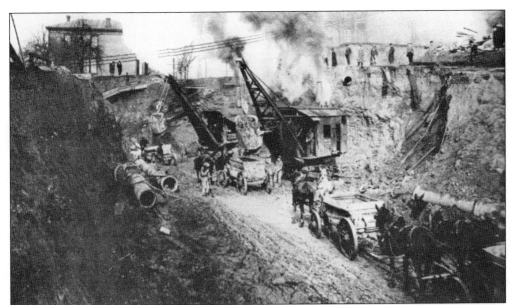

In these Asahel Curtis images, crews use the best technology of the time to move away the hill's western side, in some cases moving houses on skids before shoveling away the land beneath them. According to a 1926 report by Charles Evan Fowler to the American Society of Civil Engineers, "The regrading of Seattle . . . approached the magnitude of the material to be handled, the digging of the Panama Canal, and in some respects the difficulties were much greater." (Both Julie Albright collection.)

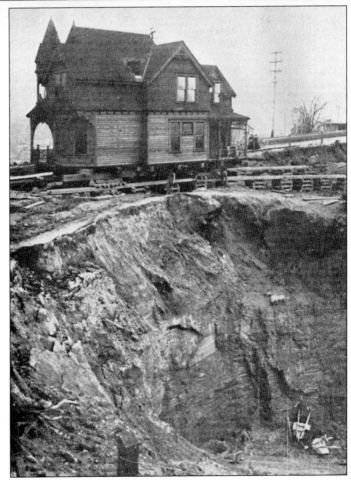

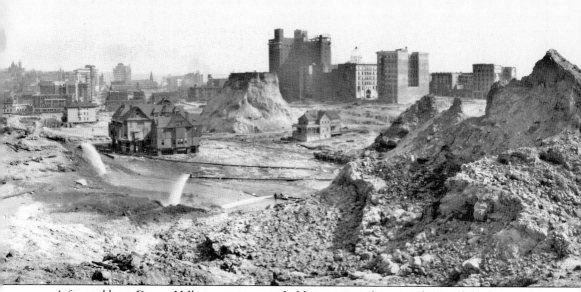

A few stubborn Denny Hill property owners held on even as the ground around them was taken away. These spite mounds became some of the most eerie, and most republished, images of the regrade process. Their owners continued to occupy their homes and rooming houses, using ever-taller stepladders to access them; until, one by one, they struck deals with the city to vacate. By 1911, the last holdouts had sold out. In this 1910 James Lee photograph, one of the final spite mounds sits forlorn with two newer houses surrounding it. In the center background from left to right are the New Washington, Moore, and Commodore Hotels. Sluicing crews are washing away dirt in the lower left corner. (MOHAI, No. 9224.)

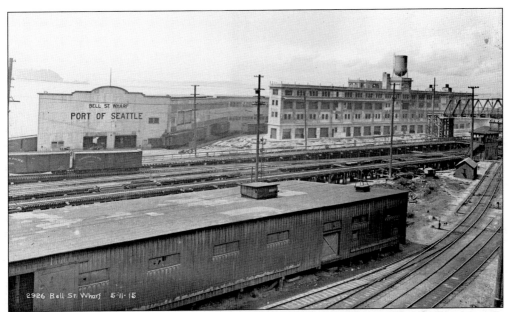

There were other regrades in central Seattle besides the ones at Denny Hill. Third and Fourth Avenues downtown were lowered, as was Dearborn Street southeast of downtown. Some of the dirt acquired in these operations went toward grading and filling the waterfront bluff. One result of this was that Belltown grew to the west as well as to the east. In 1914, the Port of Seattle established its first offices at the new Bell Street Pier. It has since become a cruise-ship dock and museum (see page 106). (Seattle Municipal Archives, No. 718.)

This 1915 Belltown streetscape, photographed from the Bell Street Pier, includes several prominent buildings still standing today. The Seattle Empire Laundry, toward the left, became the 66 Bell Street artist-studio spaces in the 1980s, and is now townhome lofts. The brick building in the center with the flagpole, the Union Stables, became an illicit warehouse for rumrunners during Prohibition and is now part of Continental Furniture. (Seattle Municipal Archives, No. 726.)

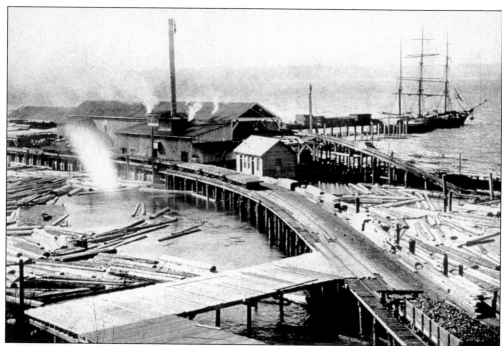

This Seattle Water Department image shows a pier and lumber mill on the waterfront. Even after the first regrade, many piers were only connected to dry land by trestles and would be until the 1930s. (Seattle Municipal Archives, No. 147166.)

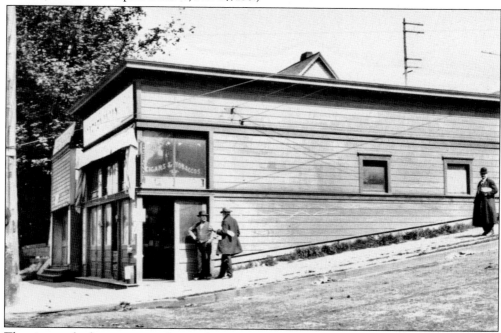

The cigar and tobacco store at the northeast corner of Western Avenue and Wall Street in this 1909 image was replaced the following year by a brick building of the same size, which eventually housed an industrial paint store. That building survived until 2000. Luxury apartments and a convenience store are there now. (UWSC, No. LEE18.)

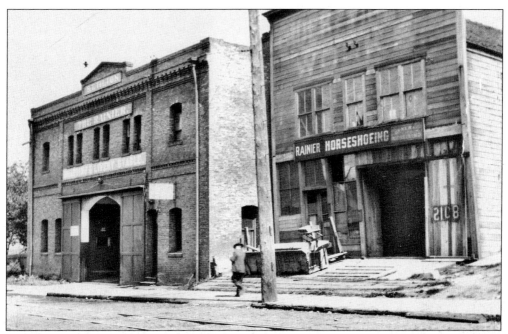

Among Reginald Thomson's stated reasons for making Seattle flatter was to make it more navigable by horse-drawn transport. Of course the automobile soon made that superfluous. (The first mass-market car, Ford's Model T, debuted in 1908.) Western Avenue's string of stables, where the horses that moved downtown's cargo slept, was phased out by the 1920s. (UWSC, No. LEE29.)

David Denny (Arthur's younger brother and another of Seattle's founders) established the city's first cemetery in 1861 at the corner of Dexter Avenue and Denny Way (which, at the time, were little more than wagon trails through the forest of east Denny Hill). A fire destroyed all of the wooden grave markers in 1882. Two years later, Denny gave the land to the city to become Seattle's first city park. The graves were exhumed and reburied at Lake View Cemetery on Capitol Hill. Denny Park was relandscaped as a tree-lined open space where residents of a rapidly growing city could take in some fresh-air relaxation. (Seattle Municipal Archives, No. 28967.)

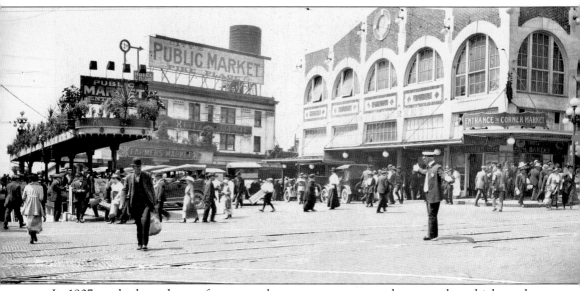

In 1907, as the legend goes, farmers and consumers were openly angry about high produce markups imposed by wholesale commission houses. The city council responded by authorizing a Saturday farmer's market at First Avenue and Pike Place. It was so popular that it became a full-time endeavor, as seen in this 1919 view, with permanent sales stalls surrounded by a labyrinth of shops, restaurants, and residential hotels stretching north to Virginia Street. The market began to decline in World War II when the Japanese American internment removed many farmer-vendors. By 1963, some city leaders wanted to scrap the whole decaying bazaar. A plan emerged in 1969 to replace it with office towers using federal, urban-renewal funds. Community activists revolted, led in part by architect-preservationist Victor Steinbrueck (1911–1985). In a 1971 initiative, Seattle residents voted to preserve and restore the market. Since then, it has been a civic icon and a world-famous tourist draw. (Seattle Municipal Archives, No. 12682.)

The Moore Theater and Hotel (seen here in 1946), named for developer James A. Moore (1861–1929), opened at Second Avenue and Virginia Street on December 28, 1907, with *The Alaskan*, a play about the 1897 gold rush. Over the next century, the 2,400-seat house would host vaudeville revues; touring Broadway shows; boxing matches; jazz and rock concerts; the first stage version of the rock opera *Tommy* (with a young Bette Midler); and the first Seattle International Film Festival. The hotel's original amenities included a swimming pool and a 24-hour restaurant. (MOHAI, *Post-Intelligencer* collection, No. 24476.)

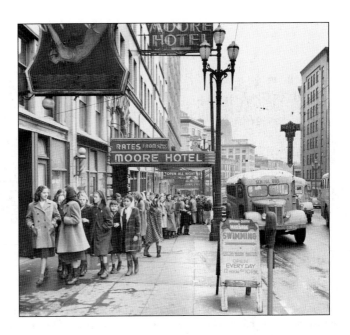

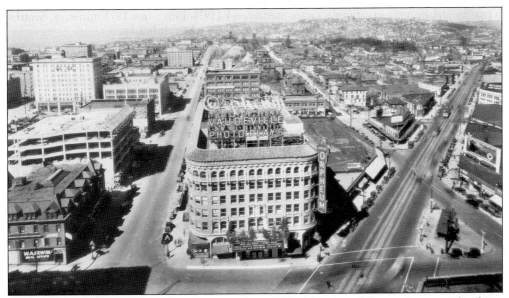

The Orpheum Theater opened in August 1927 at Fifth Avenue and Stewart street with a huge sign promising "vaudeville" and "photoplays." It was originally called the New Orpheum because a prior theater of that name had operated since 1911 at Third Avenue and Madison Street. Vaudeville acts soon gave way to an all-cinema schedule (though for a while it was home to the Seattle Symphony). The 2,700-seat house was among architect B. Marcus Priteca's masterworks, featuring a marble-walled lobby and 131 chandeliers. (Seattle Municipal Archives.)

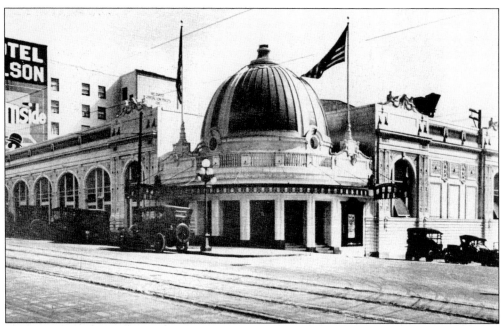

The Crystal Pool was built in 1914 by the C. D. Stimson Company and was designed by B. Marcus Priteca, who also designed downtown Seattle's Coliseum Theater and Tacoma's Pantages Theater. A glass roof and steel trusses spanned the swimming pool and 1,500 spectator seats. Saltwater was piped in from Elliott Bay and was then heated by huge iron boilers in the basement. Neoclassical terra-cotta facades adorned the exterior. (UWSC, Hamilton 87-2.)

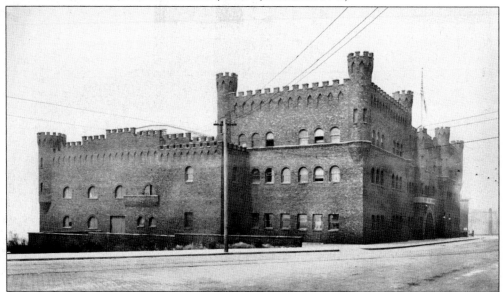

The National Guard Armory was built in 1909 on Western Avenue north of Virginia Street. Paula Becker, writing at HistoryLink.org, called it "a hulking crenellated fortress." It hosted more balls, automobile shows, and other public events than military drills. Among them was Seattle's only dance marathon, which ran 24 hours a day for 19 days in 1928 (entrants received 15 minutes of rest each hour). The armory was razed in 1968; the Victor Steinbrueck Park is there now. (Washington State Historical Society.)

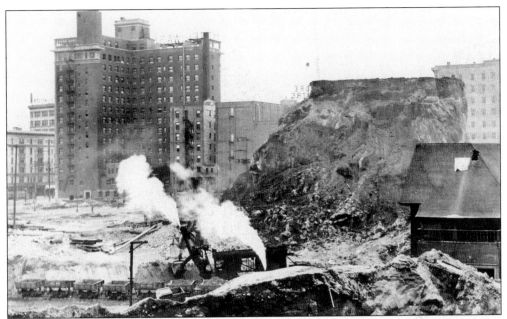

James Moore finally let the Washington Hotel be regraded in 1906. He built the New Washington at Second Avenue and Stewart Street (directly south of his namesake theater). It was sold in 1963 to the Catholic Archdiocese of Western Washington. The church now runs it as the Josephinum low-income apartments; the ground-floor banquet room is now St. Joseph's Chapel, the only place in western Washington serving the traditional Latin mass. (UWSC, No. UW27058.)

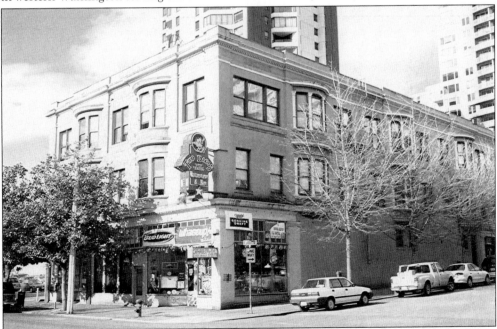

The Pacific Hospital was founded in 1900 by Paris-born Dr. Adrian Monod as a private, for-profit hospital at First Avenue and Vine Street. It was bought the following year by Dr. Charles Neville, who commissioned a new building in 1904. The hospital folded in 1915. The building became the New Pacific Apartments, briefly seen in the film *The Fabulous Baker Boys*. (Author's collection.)

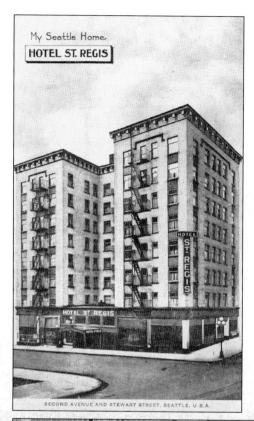

My Seattle Home.

HOTEL ST. REGIS

SECOND AVENUE AND STEWART STREET, SEATTLE, U.S.A.

Silas Archibald, a former co-owner of the New Washington, opened the St. Regis Hotel at Second Avenue and Stewart Street in 1909. Warren Milner designed the eight-story, 140-room building. He also designed the Moore Theater and the Trianon Ballroom. A speakeasy and casino operated in the St. Regis Hotel's basement in the 1920s. During World War II, it became a recuperation station for seriously injured servicemen. The building has since been rehabbed for low-income housing by the Plymouth Housing Group. (UWSC, No. UW27059.)

The Gibson House in the St. Regis Hotel was a classic among the lowbrow First Avenue bars. In its early days, prostitutes often met clients in the bar and then led them to hotel rooms upstairs. The Gibson had become a rock club when its last owner, Tony Tsui, closed it without notice in mid-2001. The "fusion cuisine" restaurant Qube is there now. (Author's collection.)

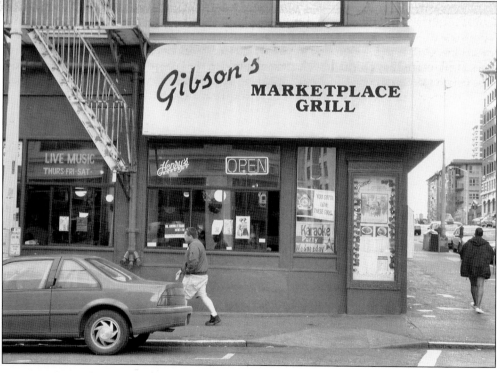

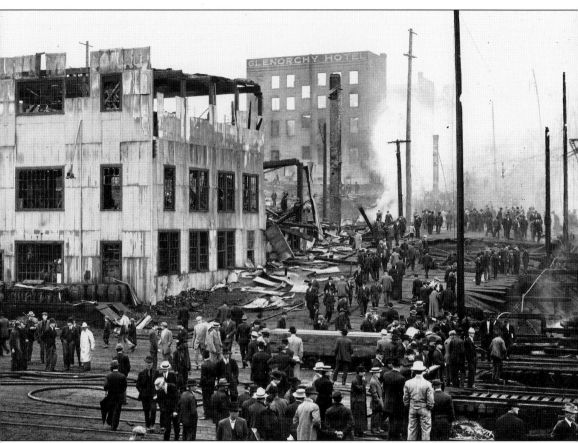

Twenty-one years after the great Seattle fire destroyed much of downtown, Belltown had its own monster fire. On the night of June 6, 1910, wind blew stray sparks from a Great Northern train to a stable. A pile of feed hay caught fire. The flames spread in the late-spring breeze. Dozens of wood-frame buildings burned overnight. Nearly 1,000 people lost their homes and businesses; 35 horses died. Portions of eight blocks were consumed in the flames. (MOHAI, No. 1983.10.8649.1.)

These two images show the low-rent district that most of the regrade became. The above picture shows Second Avenue north from Lenora Street in 1915, bearing streetcar tracks down its middle and dotted along both sides with single-family homes and rooming houses. The image below shows Second Avenue south from Bell Street in 1920, with low-rise commercial buildings having replaced the houses. The National Sheet Metal Building to the right became the Art in Form visual-arts bookstore in the 1980s, the Wall of Sound record store in the 1990s, and a convenience store in the 2000s. (Above, Seattle Municipal Archives, No. 602; below, UWSC, No. SMR292.)

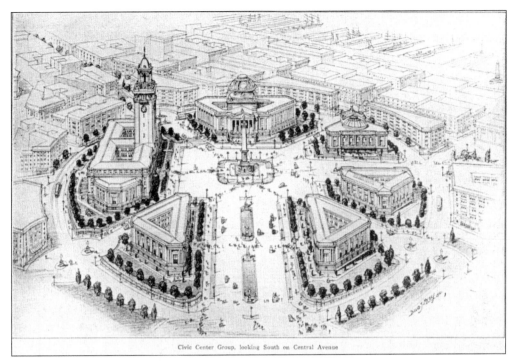

Civic Center Group, looking South on Central Avenue

In 1910, Virgil G. Bogue, a former colleague of the park-planning Olmstead brothers, was hired as Seattle's municipal planning director and was asked to design a spectacular civic plaza. He came up with a grand vision for a Renaissance-inspired complex of government buildings in the recently flattened regrade. It was part of an even bigger plan of improvements, including a rail-transit tunnel under Lake Washington to Kirkland and a central train station at South Lake Union. Bogue even suggested the city buy Mercer Island in Lake Washington as a city park. R. H. Thomson endorsed the scheme. But downtown landowners, fearful for their property values, spent heavily to defeat the Bogue plan in a March 1912 public vote, resulting in an almost two-to-one rejection. (Seattle Public Library, Seattle Room.)

Central Avenue, looking North to Central Station

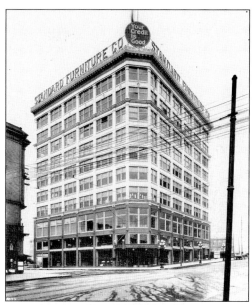

The Standard Furniture Company, with its big neon sign promising "Your Credit Is Good," was the original occupant of the 10-story Schoenfeld (now Broadacres) Building, constructed in 1907 at the northwest corner of Second Avenue and Stewart Street. The Schoenfeld family sold Standard Furniture to the Bon Marché in the mid-1930s. The Bon Marché's old rival Nordstrom now runs its Nordstrom Rack discount store in the building. A Schoenfeld's Furniture store still operates in Bellevue. (UWSC, No. UW14071.)

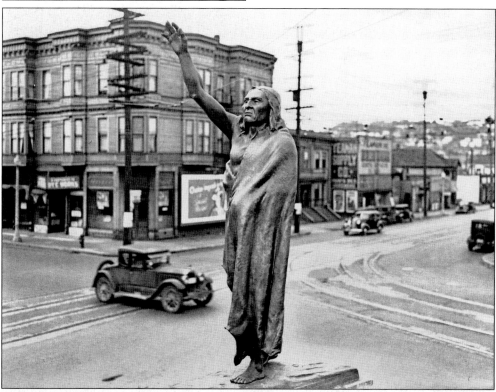

The Chief Sealth statue at Tilikum Place, near Fifth Avenue and Cedar Street, was commissioned in 1907 and finished in 1912. Designer James A. Wehn operated Seattle's first sculpture studio. "Tilikum," in Chinook jargon, means "greeting, welcome, tribe, people, relatives." A cab driver took it upon himself to restore the statue in the early 1990s using mercuric acid. City workers later stripped it of dirt and green patina to reveal its original gold-leaf coating, which has now been restored. (Seattle Municipal Archives, No. 10564.)

Seattle Fire Station No. 2, at Fourth Avenue and Battery Street, is the city's oldest operating firefighting facility. Built in 1921, it replaced an earlier structure at today's Space Needle site. When the current Station No. 2 first opened, its back wall faced the then still-standing remnants of Denny Hill, which would be leveled by the decade's end. (Seattle Municipal Archives, No. 2699.)

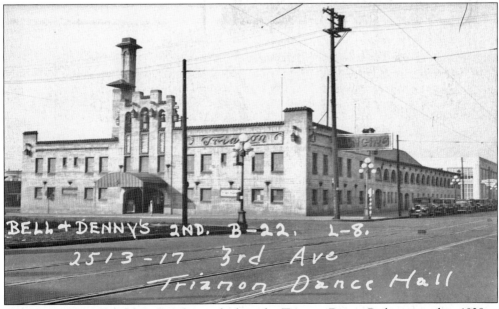

Jazz was booming, but booze was banned when the Trianon Dance Parlor opened in 1928 at Third Avenue and Wall Street. It thrived as a major swing and big-band dance hall. Seattle's own Quincy Jones played there in 1949 with the Bumps Blackwell Junior Band. In 1956, the building became the flagship store of the Gov-Mart discount chain. The facade survives in front of an office building. (Puget Sound Regional Archive.)

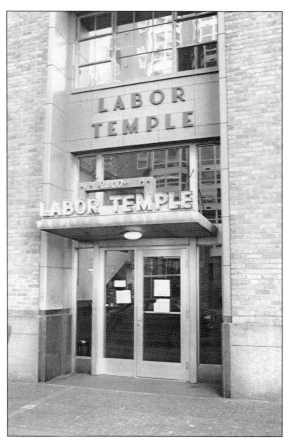

The Seattle Labor Temple was completed in 1942, one of the last projects of its type to be built before wartime shortages shut down civilian construction. It was remodeled and enlarged in the 1950s. It included a large assembly hall, a restaurant/bar, and regional offices for the American Federation of Labor (now the AFL-CIO) and several of its member unions. (Author's collection.)

The International Brotherhood of Electrical Workers (IBEW) was one of several unions with their own buildings near the Labor Temple. The 500-seat assembly room, built in 1949, hosted retro-swing dances and rock shows in its later years. In 1999, it was one of several staging locations for the protests against the World Trade Organization's convention. The union moved to Kent in 2005. This building is now a branch of the City Church, whose main sanctuary, despite the name, is in suburban Kirkland. (Author's collection.)

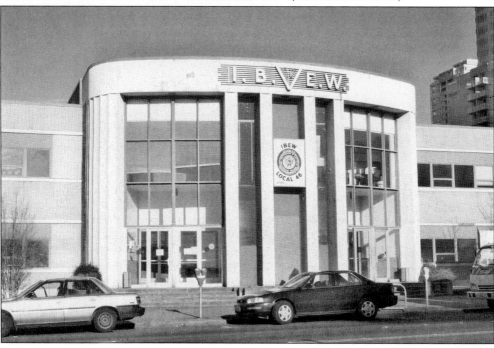

The Teamsters hall at Denny Way and Taylor Street was built in the 1930s, commissioned by the union's powerful local leader, Dave Beck. He became the Teamsters national president from 1952 to 1957, when he resigned amid state and federal fraud charges. The three-building complex was sold to condominium developers in 2005 and demolished soon afterward. (MOHAI *Post-Intelligencer* collection, No. PI24191.)

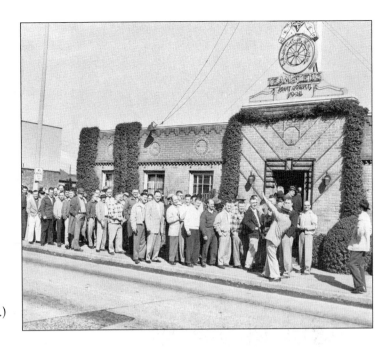

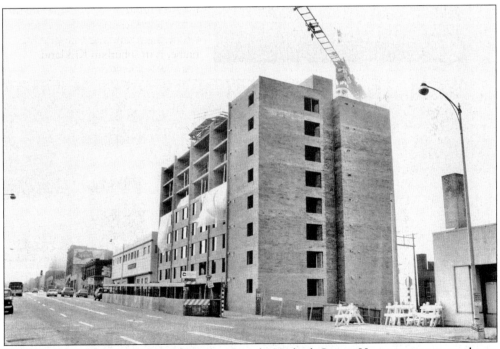

The United Food and Commercial Workers Local 1001 built Sunset House, an apartment home for its retired members, at First Avenue and Vine Street in 1977. It is now one of a half-dozen senior housing facilities in Belltown. To its left is the Sailors Union of the Pacific's green-clad building, built in 1954. That union has now moved to West Seattle, closer to the newer container docks. (UWSC, Hamilton 2053.)

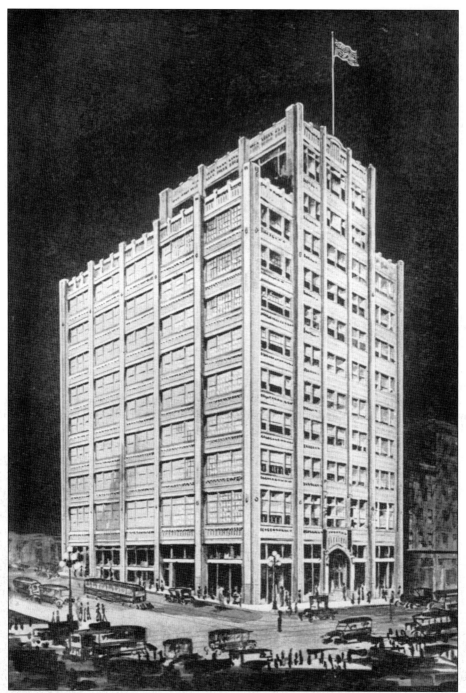

The 11-story Terminal Sales Building was built in 1923 at First Avenue and Virginia Street. Its original tenants were showrooms for companies importing apparel and other merchandise on the waterfront docks. A four-story annex building was later added across the alley connected by a sky bridge. Current management boasts that the building's 50-some tenants now include architects, graphic designers, publicists, Internet firms, and other creative companies. (UWSC No. UW27061z.)

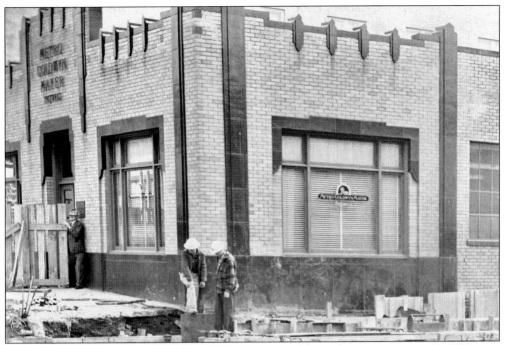

A four-block stretch of Second and First Avenues between Lenora and Wall streets was Seattle's Film Row. It was one of the industry's 31 designated regional exchange sites. Movies weren't made there, nor were they publicly exhibited, but every step in between those two took place there. Upcoming films were screened for theater managers; booking deals were made; reels were shipped away and back; and posters and publicity materials were distributed all along Film Row. MGM, Hollywood's most posh studio, boasted Film Row's most posh office, built in 1936 and seen here during Battery Street Tunnel construction in 1950. (Seattle Municipal Archives.)

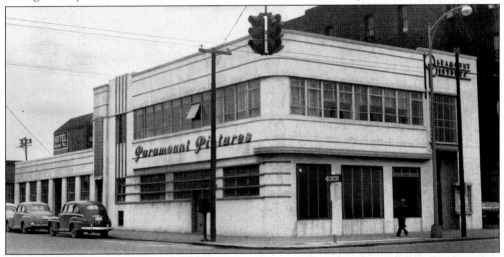

The Paramount Pictures office at 2332 First Avenue handled booking and shipping of the studio's product to theaters in four states plus the then-territory of Alaska. By 1956, the movie business was contracting while airfreight networks were growing. The Paramount Building became home to the Catholic Seamen's Union, a waterfront ministry originally founded in 1939. Today the Del Rey restaurant/lounge occupies its main floor. (Seattle Municipal Archives, No. 43071.)

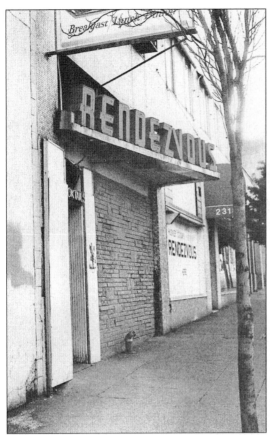

The Rendezvous restaurant, seen here in a 1995 postcard, opened in 1930 as an adjunct of the B. F. Shearer Theatrical Supply Company one block south from the Film Exchange Building. Its swanky little Jewel Box Theater was both a rental screening room for Film Row's distribution offices and an example of Shearer's theater design work. The Shearer Company folded in 1972; former Film Row worker Wayne Schwarzkopf bought the Rendezvous in 1988. (Author's collection.)

Film Row's anchor was the Film Exchange Building, opened in 1928 on Second Avenue and Battery Street. Many of the major studios, along with independent distributors and publicity firms, had offices, storage vaults, editing suites, and screening rooms in it. Universal, the last Hollywood distributor with a Seattle branch, left the building in 1980. It held other tenants, including a surplus store, until its 1992 demolition. A rocket-shaped metal sign advertising the surplus store is now a tourist attraction in the Fremont District. (Seattle Municipal Archives, No. 44246.)

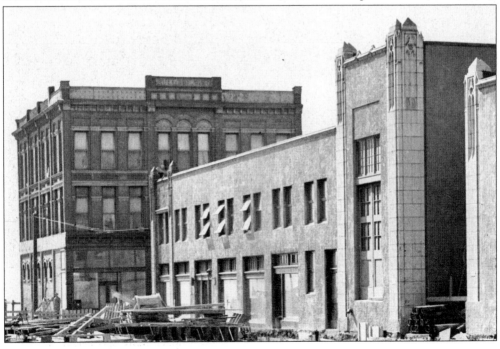

The William Tell Hotel, built in 1925, was Film Row's unofficial hostelry. Movie stars such as James Stewart occasionally stayed there; more often, studio sales and marketing officials and movie-theater managers occupied its rooms. It has since been revamped as low-income apartments. (Joe Mabel collection.)

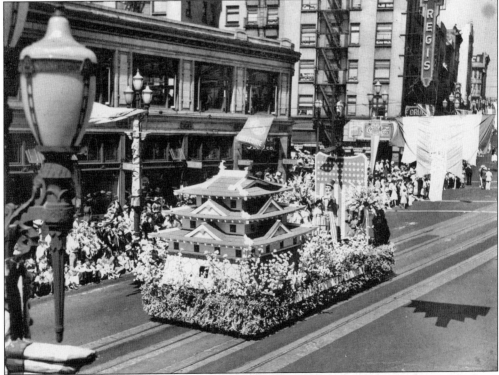

A Japanese American chamber of commerce float here travels down Second Avenue in the 1939 Golden Potlatch Parade. The civic festival began in 1911, named after a Northwest Coast native ceremony involving gift giving. It was suspended in 1914 and then revived from 1935 through 1941. World War II ended the Potlatch festivals and saw Seattle's citizens of Japanese descent forcibly shipped to inland relocation camps. (MOHAI, *Post-Intelligencer* collection, No. PI22619.)

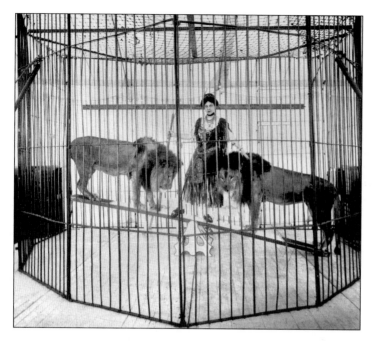

The Al G. Barnes Wild Animal Circus visited Seattle in May 1917, setting up its tents near Fourth Avenue and Lenora Street. The *Seattle Times* reported, "The rings and platforms inside the big tent are enclosed in steel grating, and inside these enclosures, the wild animals astonish the old folks and delight the children." The human appearing between the lions is identified only as Mrs. Dwyer. (MOHAI, PEMCO Webster and Stevens Collection, No. 83.10.10668.1.)

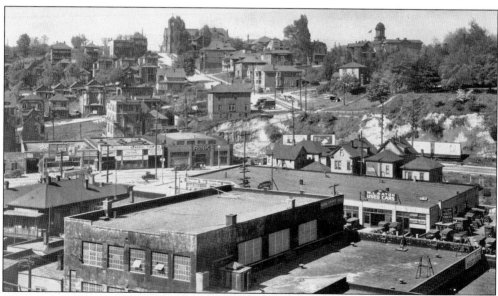

The eastern side of Denny Hill remained standing for more than 20 years. This May 1928 shot from Westlake Avenue shows Denny School and Denny Park to the upper right. They, along with the houses and church in this image, would all be gone within three years. City officials, citing a need for improved traffic flows through the city, ordered one more massive regrade. (Seattle Municipal Archives, No. 2984.)

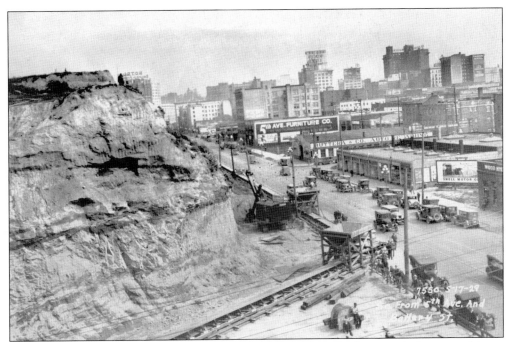

The new regrading operation took advantage of two decades' worth of progress in heavy machinery. With the automobile came gas- and diesel-powered steam shovels and bulldozers. With Henry Ford's assembly line came long-range conveyor belts. (Seattle Municipal Archives, No. 3429.)

In this June 1929 shot, one can see a steam shovel gnawing at the hill, the temporary rail tracks for the tram cars that carried away the bulldozer's work, and the network of conveyors that transported dirt from farther uphill. (Seattle Municipal Archives, No. 3469.)

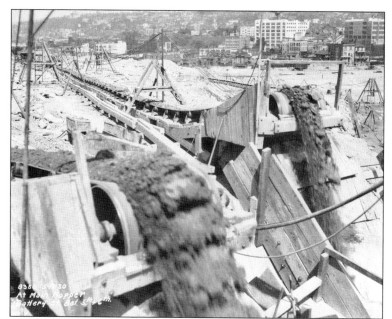

This main conveyor hopper was installed near today's Sixth Avenue and Battery Street corner. The earthmoving system shuttled the soil down to the waterfront. There it was funneled onto a self-tipping scow, towed out into Elliott Bay, and dumped. (Seattle Municipal Archives, No. 4114.)

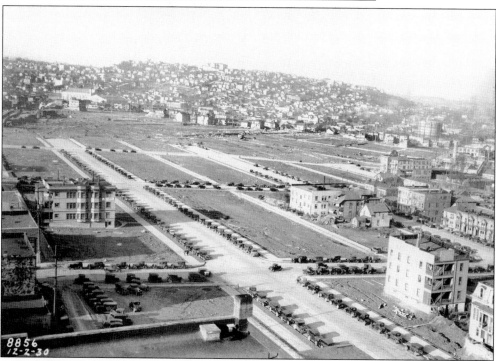

In this 1930 shot, the last regrade is almost complete. A small mound of dirt remains to be hauled away; many of the new streets and utilities have been installed. A *Seattle Times* editorial the next year commemorated the last day of work on the regrade: "In realization of Seattle's dreams of years, the removal of earth from the historic Denny Hill . . . was completed today. At last the way is open for giant new buildings, for the forward sweep of the central business district northward on level grades into territory which only a few months ago barred progress with a lofty barricade of clay banks and ill-kept, rundown residences." (Seattle Municipal Archives, No. 4558.)

Three

THE DEPRESSION AND WAR YEARS

The *Seattle Times*'s prophesied big "forward sweep of the central business district northward" was not going to happen, at least not for a long time. By the time the last regrade ended, the Great Depression was well underway. For the next 15 years, few new buildings would be constructed in the flattened Denny Triangle District. Even after that, many blocks would host low rent–district uses for several decades to come.

The pioneer Clise family acquired most of the Triangle's land. The Clises would leave large tracts for car dealerships and surface parking lots. Other blocks were developed for low-rise office buildings, restaurants, and light industry.

But was this really underdevelopment, as later commentators would claim? Every city, no matter how proud it was of its prestigious offices and its stately homes, needed a low-rent district. It needed a place where the newspapers and the sales brochures were printed. A place where cars could be fixed, trucks could be parked, and stuff could be stored. A place where more dangerous materials, such as the flammable nitrate film stocks in movie distributors' vaults, could be safely and quietly warehoused. A place where the stenographers and the stevedores could reside. A place where the people who made the city really work could dine and drink and play. For years, Belltown, and the larger Denny regrade and Denny Triangle Districts, were such places.

Denny Way became an arterial uniting Capitol Hill with the waterfront. This image is from 1949, but the only post–World War II building in it is the KOMO radio studio at left (see page 61). Across from it at 421 Denny Way, The Hub, Seattle's first lesbian bar, operated from 1950 to 1966. Zeek's Pizza is in the building now. (Seattle Municipal Archives, No. 54473.)

Denny Park was lowered 60 feet in the final regrade. It was redeveloped as a lawn with trees and paved walkways. The wooden rooftop cupola from Denny School was placed in its center, until it became too decomposed. In the 1950s, the parks department built its offices on the park's western side. Today neighborhood activists want to make the park more family friendly. One proposal would build a new Denny Hill by turning the park into a raised mesa. (Seattle Municipal Archives, No. 31478.)

The Benjamin Franklin Hotel was built in 1928 directly north of the Orpheum Theater (see page 27). It later merged into the Western (later Western International and now Westin) chain. Edward E. Carlson started his career as a Benjamin Franklin pageboy and bellhop; by 1960 he was the company president. In 1970, he engineered Westin's merger with United Airlines and became head of the combined UAL Corporation. Carlson was also one of the Seattle world's fair's main promoters and organizers; a napkin doodle, drawn after he had seen a television tower in Stuttgart, was said to be the first concept for the Space Needle. (Deran Ludd collection.)

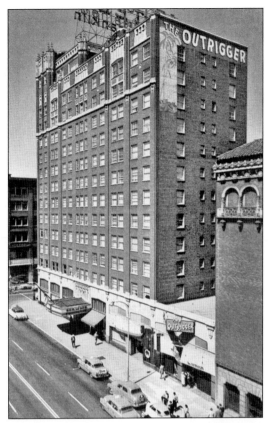

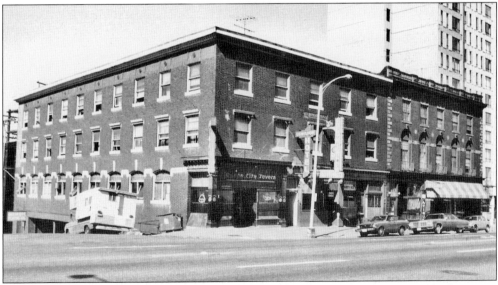

The Lewiston Hotel, seen here in 1980, was a single-room occupancy (SRO) hotel built in 1910 by Civil War–veteran Martin Paup; he acquired the First Avenue and Blanchard Street site in the 1880s. Hotels of its type had been around since Seattle's frontier days, providing short-term homes for mostly male itinerant laborers. By 1920, over 400 SRO hotels dotted greater downtown. (UWSC, Hamilton 2014.)

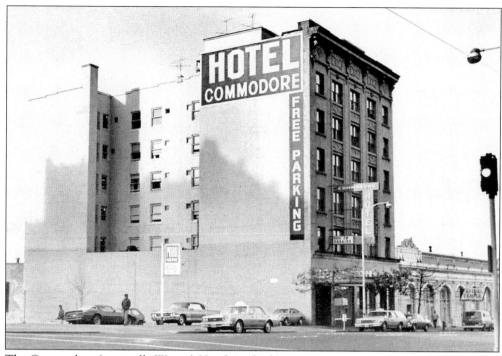

The Commodore (originally Wayne) Hotel was built in 1908, just north of Second Avenue and Virginia Street. From 1937 to 1992, its ground-floor storefronts included Orrin F. Drew Printing, one of many print shops that called Belltown home. For five years after the Drew firm's demise, the shop became the nonprofit Living Museum of Letterpress Printing. The Commodore slowly declined into a residential flophouse; its hotel status exempted it from downtown housing-preservation rules imposed in the 1980s. It was razed in February 2007. (UWSC, Hamilton 2883.)

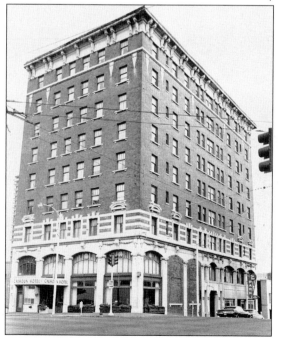

The nine-story Calhoun Hotel was built in 1913 across from the Commodore Hotel. (Second Avenue and Virginia Street had been the lowest point of Denny Hill; it had become the highest point of the regrade.) The Calhoun's basement restaurant became a speakeasy during Prohibition. Unlike the Commodore, the Calhoun attained protected status as a residential building; it is now the Palladian Apartments with an Argentinean steak house and an English pub on its ground level. (UWSC, Hamilton 16-0.)

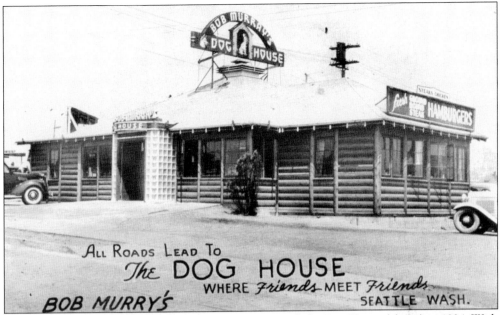

All Roads Lead To
The DOG HOUSE
WHERE *Friends* MEET *Friends*
BOB MURRY'S SEATTLE WASH.

Bob Murray, a nightclub and wrestling promoter, opened the Dog House (above) in 1934. With Murray's showmanship and a prime location at Denny Way and Highway 99, it became Seattle's top roadhouse restaurant. After World War II, Murray relocated his establishment to Seventh Avenue and Bell Street (below). The original building became a strip club in the 1990s and was razed in 2006. *Post-Intelligencer* writer John Hahn called the Dog House a place of "non-stop open-24-hours food, booze, music, and fellowship." Its menu offered goofy names for some items (such as the Bulldog and Pooch sandwiches) and warnings for others (the rib-eye steak came with the disclaimer "tenderness not guaranteed"). The waitstaff wore prim black-and-white uniforms. After Murray's death, his widow handed control to longtime manager Laurie Gulbransen. She was succeeded by her son David, who closed it in 1994. New owners reopened it as the Hurricane Café. (Both Deran Ludd collection.)

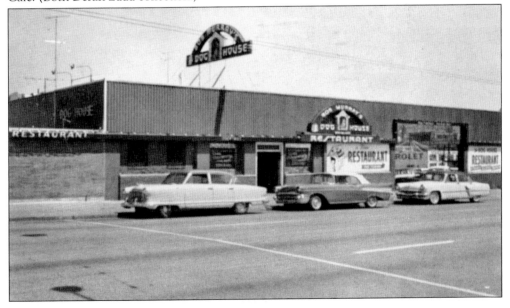

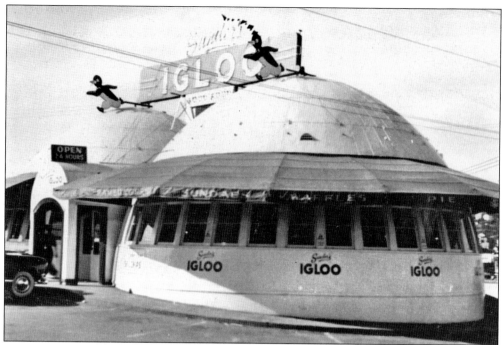

Ernie and Dorie Hughes and Ralph Grossman ran a rival roadhouse restaurant, the Igloo, at Sixth Avenue and Denny Way. A lost classic of roadside architecture, it sported a neon Eskimo atop dual metal-clad domes. Menu specialties included Husky Burgers and Boeing Bomber shakes. Open from 1940 to 1954, it offered both inside dining and carhop service. The Hugheses later worked at the Dog House. (MOHAI, No. SHS4139.)

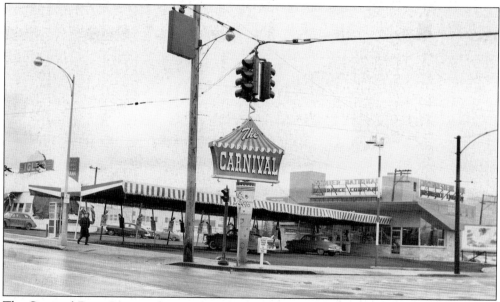

The Carnival Drive-In, next door to the Igloo, outlived the latter by four decades. By its 1995 demise, it had become Wright's Restaurant and had totally replaced its carhop parking slots with inside dining but kept the circus-inspired signage. The site now holds a Shell station, convenience store, and Starbucks Coffee stand. (MOHAI, No. 86.5.11348.1)

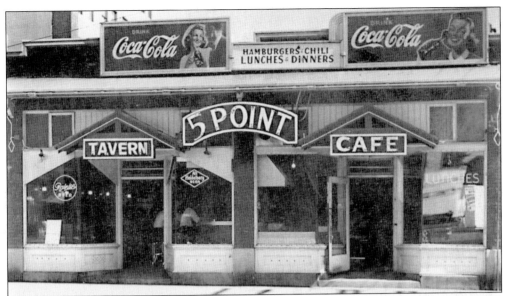

The 5 Point Café, today one of Belltown's last working-stiff diners and dive bars, opened in 1929. The building had been put up seven years before by the Webb Investment Company as a dairy warehouse. With the repeal of Prohibition in 1933, owner C. Preston Smith opened up an adjacent barroom serving beer and wine. In 1949, as restaurants in Washington could start serving hard liquor, the tavern room became a lounge. Smith's son Dick started working at the 5 Point Café in the 1950s, took it over in 1975, and ran it until his 2001 death. (Vicki Braicks.)

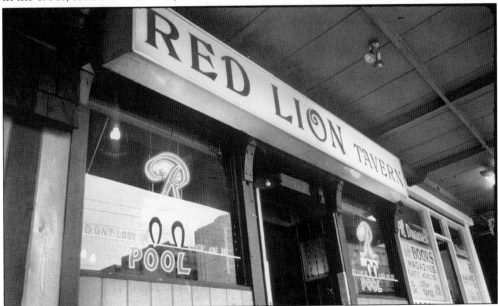

The Red Lion Tavern on First Avenue, seen here in the 1960s, was one of hundreds of small, dark storefront bars in Belltown and downtown. They served beer (also wine, but nothing stronger) to a mostly male clientele of working people and retirees. Others included the IXL; the Queen City; the Fore and Aft; Seafarers; Cohen and Kelley's; and the Cascadia. Like most of them, it has now disappeared. The site became the clothing boutique Retro Viva. (Seattle Municipal Archives, No. 34108.)

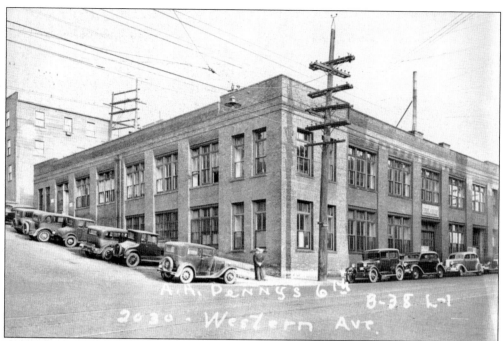

Washington State's Public Welfare Office, shown here in 1938, was located at 2030 Western Avenue. It was one of many social-service agencies, public and private, that set up shop in Belltown when it was a low-rent district. Several are still here, including Public Welfare's successor, the Department of Social and Health Services. (Seattle Municipal Archives, No. 31579.)

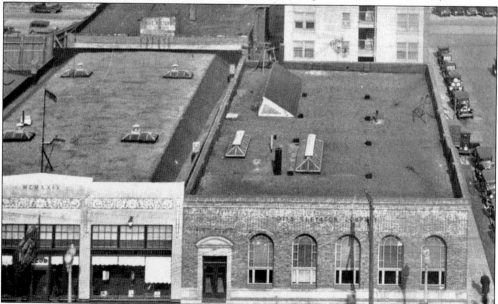

This onetime Otis Elevator sales office at Fourth Avenue and Battery Street now houses a law firm. Otis's regional headquarters are now in suburban Tukwila—in another one-story building. Some of the auto-garage buildings north of the old Otis office now house the Bad Animals recording-studio complex, cofounded by Heart singer/songwriters Ann and Nancy Wilson. (Seattle Municipal Archives, No. 3875.)

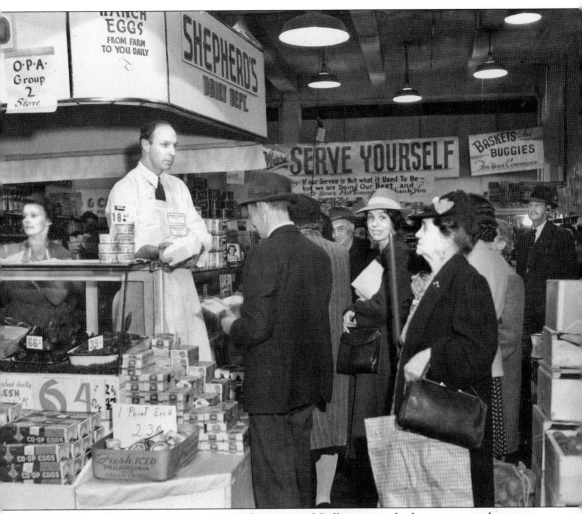

The Security Public Market, the closest thing central Belltown ever had to a supermarket, was an annex to the Securities Building, an office tower built in 1916 at Third Avenue and Stewart Street. Like Pike Place and other farmers' markets of its day, the Security Public Market's different departments were leased to different operators. The building's later occupants included Steve's Broiler (an all-night diner/lounge) and Osborn and Ulland (a sporting-goods store best known for its preseason ski sale called "Sniagrab," backwards for "bargains"). Bed Bath and Beyond occupies it now. (MOHAI, *Post-Intelligencer* collection, No. PI28117.)

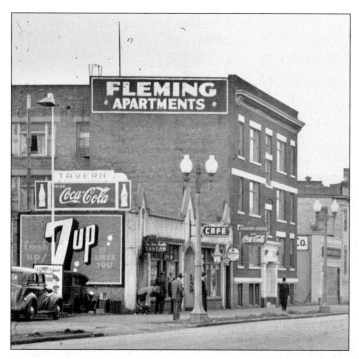

Warren Milner designed the Fleming Apartments in 1916 on Fourth Avenue south of Battery Street. A small brick building with terra-cotta highlights, it was typical of the two dozen or so walk-up apartment buildings dotted across the regrade. Since the 1980s, the nonprofit Capitol Hill Housing Improvement Program has run the building. The structure to its left in this 1944 image was constructed in 1923 as Hewitt's Café. A decade later, its left third was walled off as a separate business, the Two Bells Tavern (see page 93). (Seattle Municipal Archives, No. 40419.)

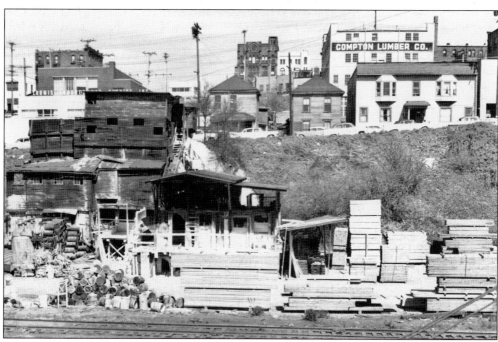

Two remaining single-family homes on Elliott Avenue can be seen in this shot of the Compton lumberyard at the foot of Battery Street along the waterfront. Compton's main building uphill on Western Avenue, constructed in 1908, originally stabled the Bon Marché's delivery horses. (MOHAI, No. 3660.)

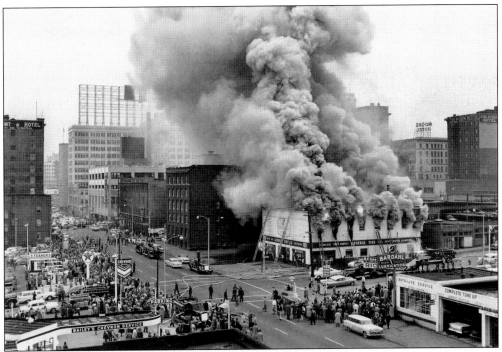

If the automobile and the suburban sprawl it engendered helped to keep Belltown underdeveloped, it also provided one of the area's principal sources of commerce. From the 1920s on, garages and gas stations were prominent neighborhood businesses. As seen in this photograph of a 1958 fire at a General Tire store, all four sides of the Fourth Avenue and Lenora Street intersection held auto-related uses. Despite its smoky appearance here, the tire store is the only structure at this intersection standing today, known now as Ralph's Grocery and Deli. (MOHAI, *Post-Intelligencer* collection, No. PI22988.)

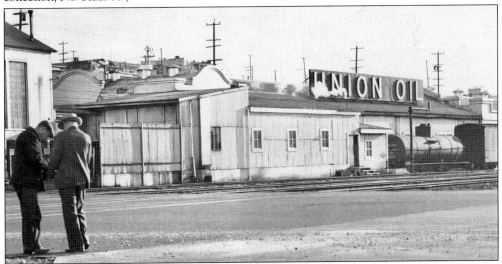

Starting in 1910, the Union Oil Company of California supplied its gas stations (later to be known under the Union 76 brand) and industrial customers via a storage depot and tank farm near the waterfront north of Broad Street. The site remained vacant for many years after its 1975 closure because of the need to clean up all the contaminated soil. (Seattle Municipal Archives.)

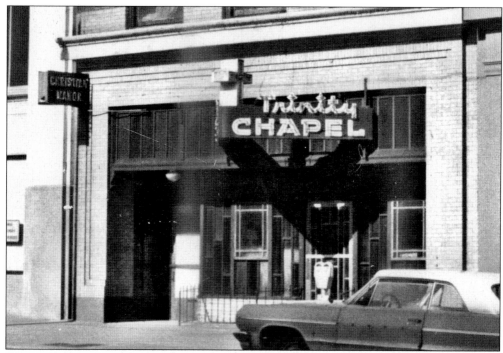

Trinity Chapel, next to the Terminal Sales Building on First Avenue, was one of several storefront churches and missions that set up shop in Belltown. Some were specifically formed to minister to the area's downtrodden and/or elderly residents. (Seattle Municipal Archives, No. 33162.)

After the Crystal Pool (see page 28) closed as a swimming facility, it was used as a boxing gym/auditorium and a roller-skating rink. In 1944, it became the Bethel Temple nondenominational church. Its altar, at the front of the filled-in pool, featured a white neon cross above a neon sign reading "I Will Glory in the Cross." Bethel sold the building in 1999 to developers to help endow the church's ministries to Seattle's poor and homeless. The developers demolished the building in 2003 but kept the terra-cotta facade as part of the new Cristalla condominium tower. (UWSC, Hamilton 87-1.)

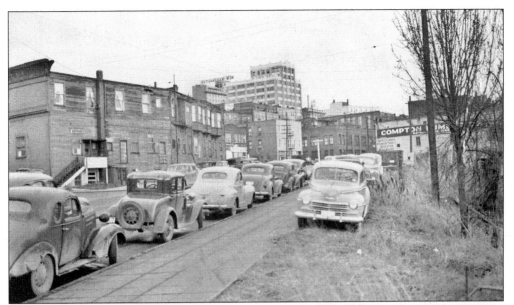

Elliott Avenue was one of the key arterials toward the waterfront. It was still very much a working harbor then, and Belltown was a major part of its connection to the city and the world. (Seattle Municipal Archives.)

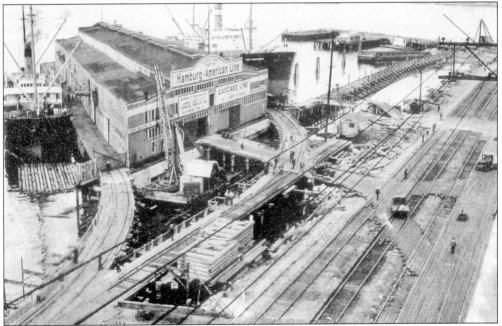

Railroad Avenue, later renamed Alaskan Way, was a wooden street built atop rotting timber piles. The actual shoreline was located much further east and would have reached present-day Western Avenue during high tide. A seawall and landfill were installed on the southern downtown waterfront starting in 1911. In 1934, this work extended north to the Belltown stretch of the waterfront. The fully paved Alaskan Way officially opened in 1938. Shipworms caused this road to collapse at Clay Street in 1954. Despite this, Alaskan Way's fill-dirt roadbed was used as the base for a two-tiered elevated highway. (Seattle Municipal Archives.)

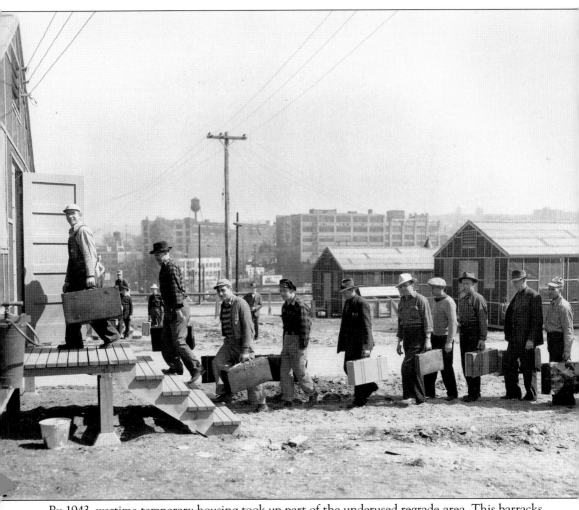

By 1943, wartime temporary housing took up part of the underused regrade area. This barracks on Fourth Avenue housed men stationed at Fort Lawton, at Boeing's airplane factories, and at other war-production facilities. These buildings were razed after the war; other projects built at the same time in other neighborhoods, including Yesler Terrace and High Point, were kept as subsidized family housing. (MOHAI, *Post-Intelligencer* collection, No. PI28137.)

Four

THE POSTWAR ERA

After the war, Belltown and the regrade/Triangle District remained places mostly filled by small buildings and small ambitions. The area was an office and union-hall district for the adjoining waterfront to the west and a low-rent district of support services for the downtown towers to the south. One of these businesses was printing. Presses and binderies, such as Consolidated Press, Craftsman Press, Metropolitan Press, and News Publishing, abounded.

And where printing presses went, so did the publishers whose content kept those presses busy. Periodicals published in Belltown over the years have included the *Seattle Weekly* (the city's longest-lived "alternative" tabloid, once housed beneath Sub Pop records in the Terminal Sales Building), *Argus* (a political insiders' forum, run for many years by Olympic Stain tycoon Philip Bailey), *The Rocket* (a music guide where the 1980s–1990s grunge bands got some of their first publicity), and *Real Change* (an activist weekly sold by the homeless). Neighborhood-oriented publications have included *The Belltown Rag, Belltown's Brain Fever Dispatch*, the simply named *Belltown Paper*, and the current *Belltown Messenger*.

Then there was the *Seattle Post-Intelligencer*, the publication that called itself "the Voice of the Northwest" and that built a structure to match its boastful stance.

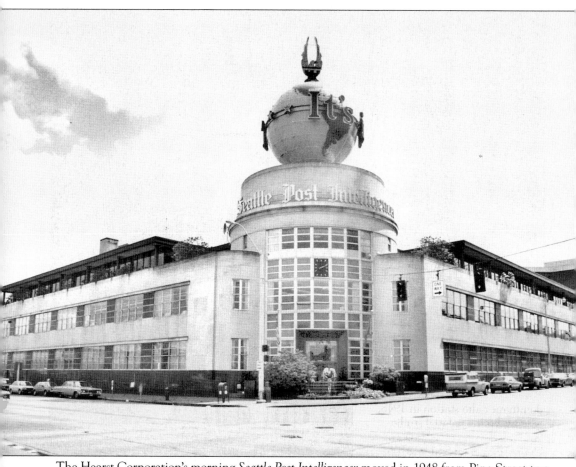

The Hearst Corporation's morning *Seattle Post-Intelligencer* moved in 1948 from Pine Street to a streamlined, full-block, two-story building at Sixth Avenue and Wall Street. (A third level was added in the 1970s.) The paper held a contest for the building's centerpiece sign. University of Washington art student Jakk Corsaw won with a steel and neon globe topped by Hearst's mascot eagle and encircled by the moving letters "It's in the P-I." The paper moved out in 1986 and took the globe to its new Elliott Avenue offices near the waterfront. The Group Health medical co-op later had offices in the former Post-Intelligencer Building, but it announced plans in 2007 to move out. (UWSC, Hamilton 4180)

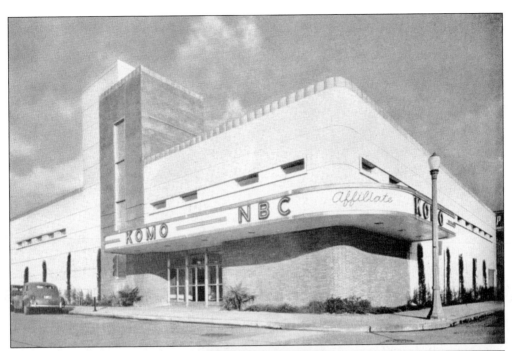

KOMO-AM had been owned by the Fisher family, local flour and real estate titans, since its 1926 sign-on. It was the region's dominant radio station in 1948, when it built a palatial studio building at Fourth Avenue and Denny Way. The building was designed with future television expansion in mind. But thanks to the Truman-era Federal Communication Commission's freezing of station applications, KOMO-TV didn't launch until December 1953. By 1956, it boasted the Northwest's first local color programming. (The "NBC Affiliate" sign on the building would be removed by 1959 when KING-TV and Radio signed with NBC and KOMO was left with the then–third place ABC.) In 1999, KOMO launched the nation's first local newscast in high-definition television. (Both author's collection.)

BROADCAST NEWS

KOMO-TV

PRODUCT DEMONSTRATION
AT KOMO-TV COLOR CLINIC

VOL. No. 99 FEBRUARY 1958 RCA

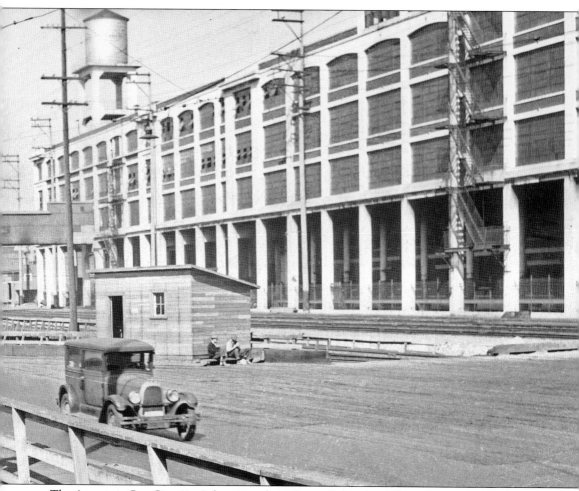

The American Can Company's factory and warehouse, located on Elliott Avenue and Clay Street near the waterfront, was built in stages between 1917 and 1925. Two-and-a-half blocks long, it spanned over 330,000 square feet of space on six stories covering 1.79 acres. For more than half a century, it supplied containers to the Alaska fishing industry, as well as to Northwest fruit and vegetable canners. The company also operated its own shipping dock at Pier 69. (Seattle Municipal Archives, No. 8737.)

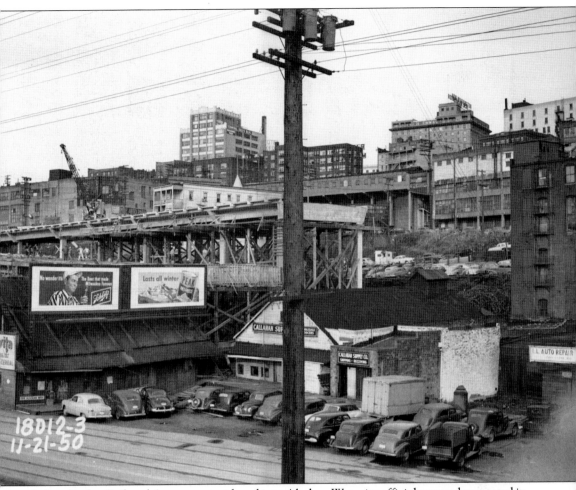

A decade after Railroad Avenue was widened into Alaskan Way, city officials wanted to expand it into a thru-highway. The two-tier elevated viaduct was built in stages between 1950 and 1959. Its current age, and its earthquake vulnerability (it was built on fill dirt), are among the reasons many politicians now want it demolished and/or replaced. (Seattle Municipal Archives, No. 43111.)

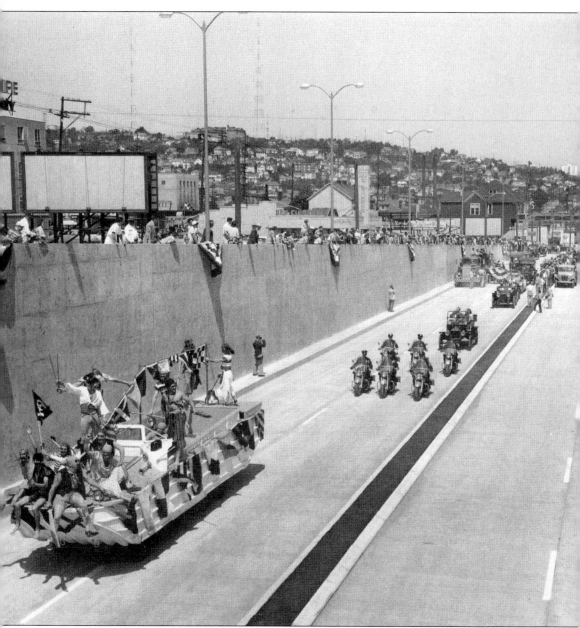

The viaduct was connected to the existing Aurora Avenue (U.S. Highway 99) by a tunnel underneath the heart of Belltown at Battery Street. The tunnel's 1954 grand opening was celebrated with a parade, here featuring the Seafair Pirates and a police escort. (MOHAI, *Post-Intelligencer* collection, No. 1986.5.12268.1.)

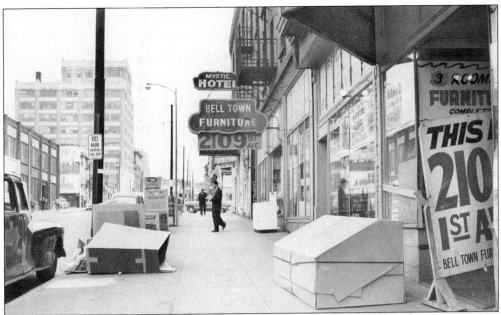

Bell Town Furniture was opened in 1946 near First Avenue and Lenora Street. Founder Al Moscatel had previously sold sundries in the Pike Place Market. The store was the subject of frequent complaints by city officials who disliked its unsightly signage and sometimes-obtrusive sidewalk displays. It is now the much more stylish Continental Furniture, still run by the Moscatel family. Their other firm, Allegra Properties, is among the neighborhood's biggest landowners and developers. (Seattle Municipal Archives, No. 52617.)

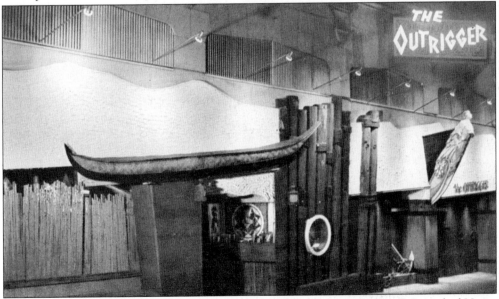

The Outrigger by Trader Vic opened in 1948 in the Benjamin Franklin Hotel. It marked Victor Bergeron's first expansion beyond his original Oakland, California, location. It was later rechristened under the regular Trader Vic's brand. Under manager Harry Wong it served countless fruity and rummy cocktails, and pan-Asian entrees until its 1991 closure. Some of the decor now hangs at the Crocodile Café. A new Trader Vic's opened in Bellevue in 2006. (Deran Ludd collection.)

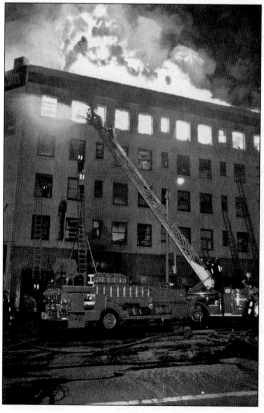

The Ozark, at Westlake Avenue and Lenora Street, was a single-room-occupancy (SRO) hotel. The wooden structure, with 60 rooms on five stories, had been around since at least 1917. By the 1960s, the Ozark's exterior signs promised "color TV in every room;" like the other SRO hotels, its main clientele had become older single people and low-income males. At 2:30 a.m. on March 20, 1970, an arsonist set two small fires that swept up the Ozark's stairways. Fourteen men and six women died, and 15 others were injured. No arrests were made. The city council responded with stringent new fire codes. Among other provisions, the codes forced hotel and apartment owners to add sprinklers and fire doors. Scores of SRO hotels, already barely profitable, closed instead of spending money to renovate. Within a decade, downtown's residential population dropped by more than half. (Above, Seattle Municipal Archives, No. 54450; left, Richard Schneider collection.)

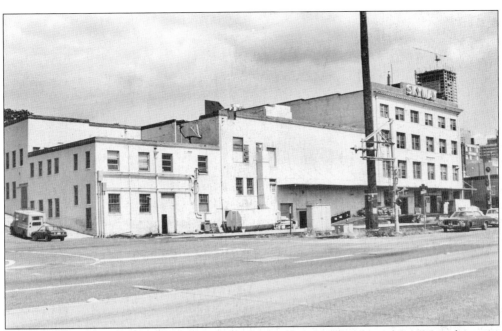

Skyway Luggage was founded in 1910 as the Seattle Suitcase, Trunk, and Bag Manufacturing Company. In 1987, at the suggestion of a Northwest Airlines pilot, it introduced the world's first wheeled suitcases. Run today by third-generation family leader Henry "Skip" Kotkins, its world headquarters is still at 30 Wall Street; the building once bore a neon sign along its south wall depicting an ascending jet plane. Its products are now made in Asia. (UWSC, Hamilton 2649.)

Archie, Dean, and Eldon Anderson opened Seattle's first fully automated car wash in 1951 in the south end. Their second Elephant Car Wash, opened in 1956 on Battery Street, was an even bigger success. Its landmark pink neon has been seen worldwide in movies, TV shows, and music videos. (Author's collection.)

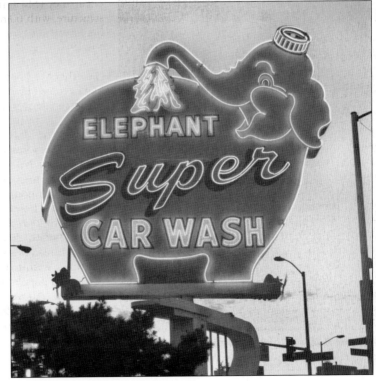

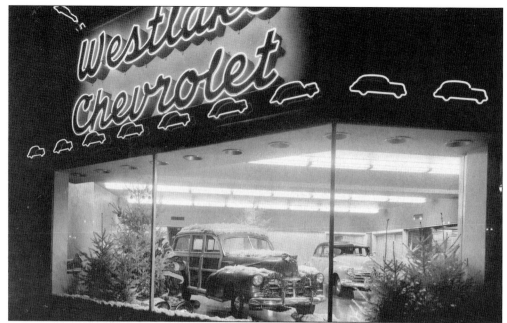

While Capitol Hill's Pike-Pine Corridor was Seattle's first auto row, the Denny Triangle and adjacent districts became central Seattle's primary home for car dealerships. Westlake Chevrolet was one of over a dozen lots offering Cadillac, Pontiac, Oldsmobile, Ford, Lincoln-Mercury, Dodge, Volkswagen, Volvo, Nissan, Land Rover, and other makes over the years. Toyota and Honda stores remain. (MOHAI, PEMCO Webster and Stevens collection, No. 483386.)

The Martin Cinerama Theater opened in 1963 at Fourth Avenue and Lenora Street. By that time, the original three-strip Cinerama process had been discontinued; single-frame Cinerama films would be made for another six years. The theater enjoyed a longer life; its curved screen and 800 plush seats made it the city's premier film palace. Microsoft cofounder Paul Allen bought and lovingly remodeled it in 1998. (Author's collection.)

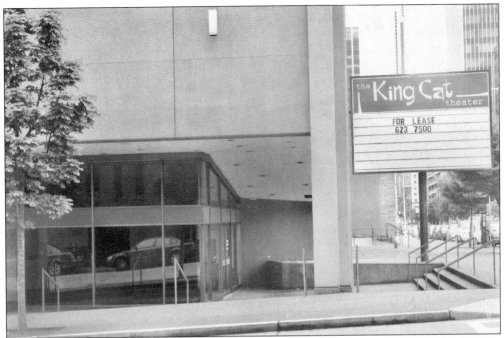

The 500-seat King Theater was built by the Walter Reade chain in 1974; it was Seattle's last new single-screen cinema that wasn't remodeled from an existing building. In the early 1990s, it hosted live jazz and rock concerts as the King Cat, including a Nirvana-headlined benefit in 1993. A Pentecostal church later occupied the building, vacating it in 2007. (Author's collection.)

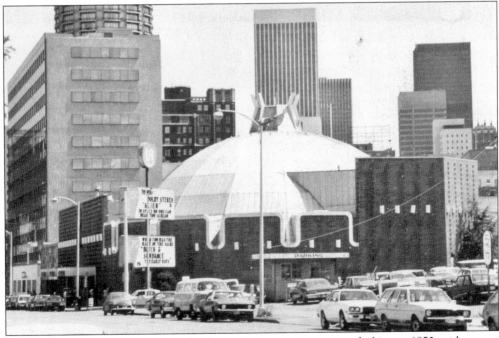

The United Artists 70/150 was Seattle's first twin cinema. It was named after two 1950s wide-screen fads, 70mm and Dimension 150. Its biggest draw was the original *Star Wars* in 1977. It had become a discount cinema when it closed in 1998; it was razed four years later. (UWSC, Hamilton 71-76.)

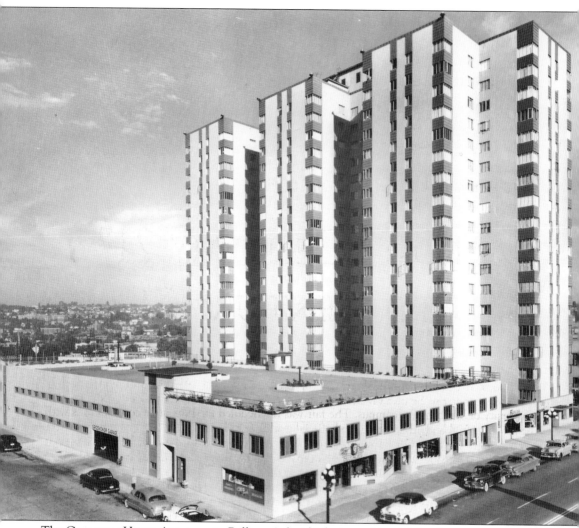

The Grosvenor House Apartments, Belltown's first high-rise residential development, was built in 1951 across from the Post-Intelligencer Building on Wall Street. Former national Teamsters leader Dave Beck was one of its principal investors. The 18-story building featured 356 living units, a parking garage with a private rooftop garden, and street-level retail spaces, including a convenience grocery, a florist shop, and the plush Grove Restaurant. Originally one of Seattle's most posh addresses, by the late 1980s it was being marketed as a senior citizens' building. Denver investors bought it in 2000 for $38 million before selling it in 2007 for $82 million. (Tacoma Public Library, Richards Studio Collection, A61034-1.)

Five

FROM "CENTURY 21" TO CENTURY 21

Civic boosters originally planned the Century 21 Exposition for 1959, the 50th anniversary of another event to put Seattle on the map, the Alaska-Yukon-Pacific Exhibition at the current University of Washington campus. The fair was rescheduled for 1962 after consultations with the international body that sanctioned official world's fairs.

Organizers sited the fair between Denny Way and Mercer Street north of Belltown. That neighborhood already had a high school football stadium, a Shriners temple, an auditorium, an armory, and a hockey arena, all of which the fair used.

The downtown business leaders wanted to make sure fairgoers would visit the retail core instead of hanging around the regrade. Thus a futuristic elevated train was planned as one of the fair's signature attractions. The Alweg Monorail, named for its German builder, quickly shuttled tourists between the fair and the department stores, bypassing Belltown and leaving the neighborhood quiet—except for the trains' regular rumbles above Fifth Avenue. The system marked eight million rides during the fair's six-month run. After the fair's closure, some landowners along Fifth Avenue were angered to learn the monorail, which they thought was a temporary attraction, would remain up and running to the renamed Seattle Center complex. Remain it did, carrying an average of 2.5 million passengers per year.

Thirty-five years later, part-time cab driver Dick Falkenbury began distributing initiative petitions, seeking a new citywide monorail network. With a handful of volunteers and no support, the initiative gathered 18,500 signatures while spending only $2,000, sending the initiative to a public vote. City voters approved the initiative, creating the Seattle Monorail Project. Two more successful votes followed, authorizing a 14-mile starter line that would replace the existing 1.2-mile monorail. A fourth election approved a tax on vehicles to pay for the project. But after project staff issued an $11 billion cost estimate, real estate developers and the highway lobby promoted a fifth vote in 2005 in which Seattle voters killed the new monorail dream.

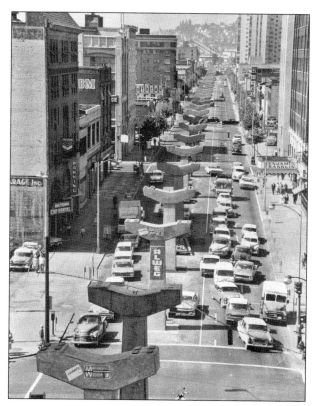

According to the Century 21 Exposition's *Official Guide Book*, "The [monorail] track is three feet wide and five feet deep. It is made from pre-cast concrete, supported by T-shaped concrete columns. The columns are placed 85 feet apart on the straightaway and 60 feet apart on the curves. More than 15,000 tons of steel were used in the monorail system." (MOHAI, No. 1986.5.9867.)

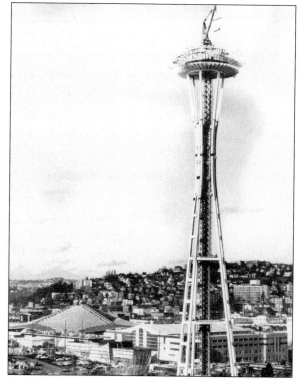

The first concrete for the Space Needle was poured on May 22, 1961, and Pacific Car and Foundry (now PACCAR) began work on the steel superstructure. The company designed a special derrick and hoist that grew upwards along with the structure to lift the sections of the Space Needle into place. (MOHAI, No. 1965.3598.3.10.)

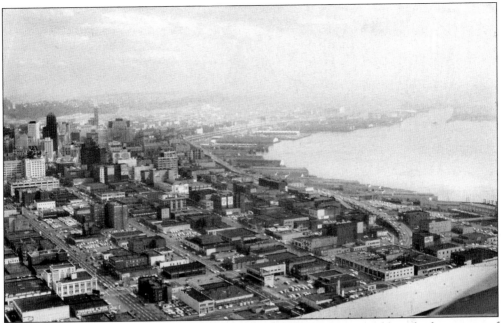

Tourists on the Space Needle's restaurant and observation decks enjoyed breathtaking views of Elliott Bay; the Olympic and Cascade mountains (weather permitting); the downtown office towers; Queen Anne and Capitol Hills; and, at no extra charge, Belltown's mostly undistinguished-looking, low-rise blocks. (Author's collection.)

The Canadian Pacific Railway launched passenger boat service between Seattle and Victoria, British Columbia, in 1924 with the 352-foot steamer *Princess Marguerite*, named for the daughter of a CP executive. That ship was later pressed into World War II troop/transport service and was sunk by a U-boat off Port Said in 1942. A second *Marguerite* was built after the war, serving the Seattle-Victoria route in stoic luxury until 1991. Today the Victoria Clipper line operates a fleet of smaller but faster ships. (UWSC, Hamilton 2646.)

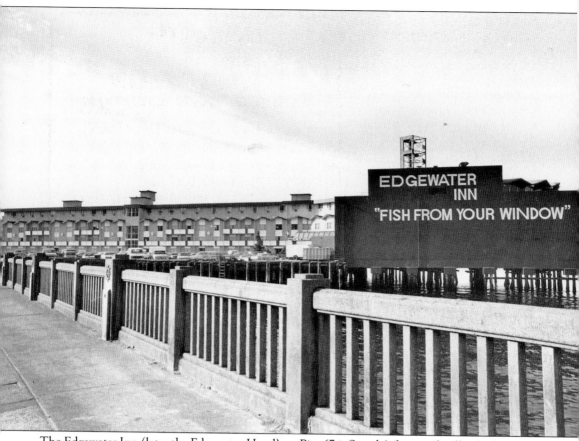

The Edgewater Inn (later the Edgewater Hotel) on Pier 67 is Seattle's first, and still only, hostelry on the water. It was built in 1962 as part of a hotel-and-motel building boom accompanying the world's fair. After the fair, the Edgewater might have become just another place to stay—albeit one where a person could fish from the window—but for an ingenious move by then-owner Don Wright to attract a new class of business travelers. As the Beatles' 1964 U.S. tour was being organized, all of Seattle's other top hotels wanted nothing to do with the mop tops or their manic teen fans. Wright took on the challenge and its associated potential for publicity. Wright and his staff devised and executed a plan to get the idols on and off the premises, and to keep the screaming hordes out. Afterwards Wright had the hallway carpets cut up and sold to Beatlemaniacs as souvenirs. The Edgewater continued to welcome rockers—and their adventuresome groupies, as recounted in Frank Zappa's song "Mudshark." (UWSC, Hamilton D-24.)

Since its 1902 construction, Pier 70 (originally designated Pier 14) had been an international shipping dock, a state liquor-store warehouse, and a Coast Guard station. In the late 1960s, its family owners turned it into a shopping and dining attraction. Its anchors included a Pier 1 Imports store, a steak house, an outlet store for Seattle's booming youth-fashion industry, and one of Seattle's biggest dance clubs. It was remodeled again in 1995 as office-retail space. MTV's series *The Real World* was based there in 1998. (Author's collection.)

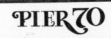

PIER 70

RESTAURANT & CHOWDER HOUSE

TWIST AGAIN
with **CHUBBY CHECKER**

May 21st—ONE NIGHT ONLY!
2 Concerts 8:30 P.M. & 11:00 P.M.
Advance Tickets Available
624-8090 for info.

LIVE MUSIC NIGHTLY
Now Playing: JOE ERICKSON
& THE GUYS
Thursday A.S.B. Night
ALASKAN WAY AT FOOT OF BROAD
"ON SEATTLE'S WATERFRONT"

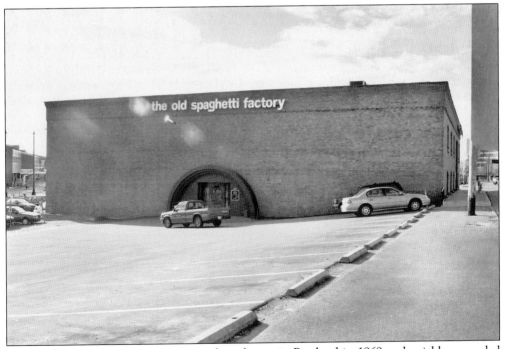

The Old Spaghetti Factory restaurant chain began in Portland in 1969 and quickly expanded into this 1902-built waterfront warehouse across from Pier 70. Generations of kids and families have feasted on its heaping servings of noodles with sauce, spumoni ice cream, and retro decor. (Author's collection.)

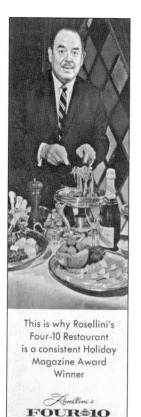

Victor Rosellini (1915–2003) opened Rosellini's Four-10 in downtown's White-Henry-Stuart Building in 1956. With that building's 1975 demolition, Rosellini's tFour-10 moved to Fourth Avenue and Vine Street, lasting until 1988. The elegant, carriage trade, dinner spot became a prime hangout for local executives and politicians. Victor's cousin Albert served two terms as Washington's governor. (Sunny Speidel; from *Seattle Guide*.)

This is why Rosellini's Four-10 Restaurant is a consistent Holiday Magazine Award Winner

Rosellini's
FOUR✦10

Crawford-Waage Hardware, on Third Avenue south of Bell Street, was founded around 1915. Its co-owner since 1951, Wallace Wolfe, was famous for his attentive air and his hands-on approach to customer service. Wolfe's death in 2002 at age 92, combined with sharp rent increases and the rise of suburban, big box chains, led his son Donald and daughter-in-law Christie to shut down. As Christie wrote in a letter to the *Belltown Paper*, "We tried, dear neighborhood, to hold on, but she has finally been lowered to her knees. . . . Thank you for your faithfulness to the store and to us." (Author's collection.)

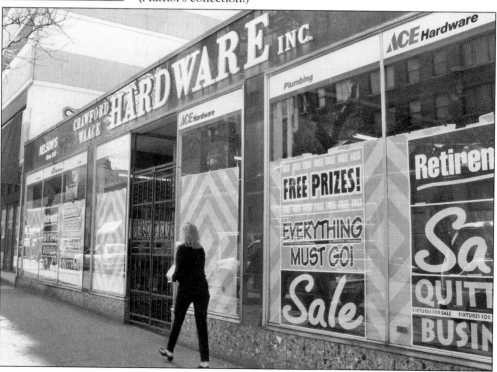

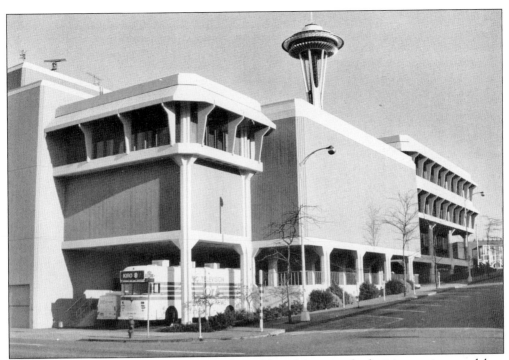

In 1958, CBS affiliate KIRO-TV was the last of Seattle's original television stations to debut. Its first home was in a former private club on Queen Anne Hill (the studio was in the former swimming pool). In 1968, it constructed its own building, Broadcast House, at Third Avenue and Broad Street. The station is still there, although two nearby annex buildings have been demolished for higher-density developments. (UWSC, Hamilton 54-4.)

The first local show on KIRO's first day starred Chris Wedes as the talkative, fun-loving clown J. P. Patches. Soon joined by all-purpose sidekick Bob Newman, Wedes remained a local hit until 1981, beloved by kids, parents, and sponsors alike. Fund-raising efforts are now underway to build a Patches statue in Seattle's Fremont District. (Chris Wedes.)

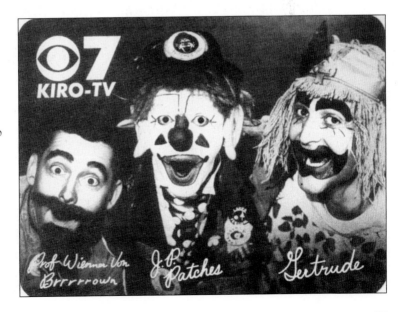

Bushell's Auction Company was family owned for its entire 1906–2002 existence. Its last 86 years were on Second Avenue north of Virginia Street. Its Tuesday morning auctions were low-key, informal rituals for collectors and antique dealers. Bushell's was known for finely picked merchandise, scrupulous sales policies, and the rejection of "modern" conveniences like credit cards and computers. The building has been preserved as offices. Ex-Bushell employee Gary Versteege now runs the Seattle Auction Company in the Georgetown neighborhood. (Author's collection.)

A rival auction house, Pacific Galleries, began in 1972 on Third Avenue. It has since moved to larger quarters in the south end as an adjunct to a giant antique mall. (Author's collection.)

In the late 1960s, the Moore Theater/Hotel's restaurant became the Firelite (later the Nitelite), one of the Colacurcio family's string of topless clubs. Frank Colacurcio Sr. regularly got in legal trouble over cash skimming and bribery charges. *Seattle Weekly*'s Rick Anderson described him as "a stocky rock of a man, 5-7, 180 pounds, a fisherman when he wasn't angling for money and women, who flashed a well-practiced angelic smile." The Nitelite is now a regular, dancer-less restaurant/bar. (Sunny Speidel; from *Seattle Guide*.)

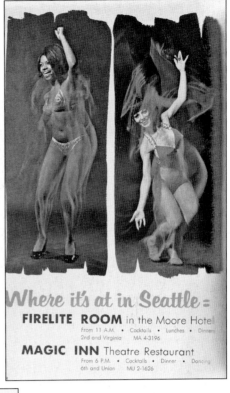

Where it's at in Seattle =

FIRELITE ROOM in the Moore Hotel
From 11 A.M. • Cocktails • Lunches • Dinner
2nd and Virginia MA 4-3196

MAGIC INN Theatre Restaurant
From 6 P.M. • Cocktails • Dinner • Dancing
6th and Union MU 2-1626

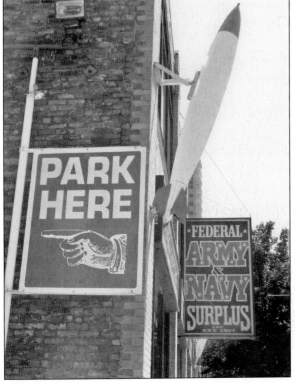

Federal Army and Navy Surplus, at 2112 First Avenue, was founded in 1917 before the United States entered World War I. It is now the last survivor of several surplus stores that once dotted Belltown, particularly in the post–World War II years. It still sells uniforms, outdoor gear, knives, and military memorabilia; newer product lines include camouflage bikinis and MREs (meals ready-to-eat). (Author's collection.)

As Edward Carlson steered Western International Hotels from a Northwest regional circuit into opening more modern facilities in bigger cities, he did not neglect the chain's hometown. He razed the historic Orpheum Theater next to Western's Benjamin Franklin Hotel in 1967 and built the circular, high-rise Washington Plaza. After the company became Westin, it replaced the Franklin building with a second cylindrical tower. (MOHAI, No. 1986.5.50524.1)

Six

RISING AGAIN

The Clise family, the Denny Triangle District's biggest landowners, first tested the neighborhood's potential for higher-density developments in 1962 by putting up the 11-story Sixth and Lenora Building, which was followed in 1968 by the Denny Building one block north.

Then the 1970 Boeing recession stalled further new projects. By the time the local economy got going again, office developers were more interested in high-rise, high-profile towers downtown and in suburban office parks.

In the mid-1970s, Seattle's population was falling as more families fled to the outskirts. The City of Seattle approved new zoning in Belltown to encourage high-rise residential construction. *Seattle Weekly* published an approving cover story with an illustration of a rebuilt Denny Hill consisting of sleek modern towers connected by sky bridges and elevated public transportation. The bridges and the trains never appeared (though the monorail initiatives of the late 1990s would have built the latter). The residential towers themselves first appeared in isolated one-off projects.

Before the high-rise residential trend got truly underway, artists, musicians, and entrepreneurs created a Belltown art scene. It was anchored by several live/work studio spaces within under-used industrial and commercial buildings. It grew to include galleries, cafes, clubs, an arts bookstore (Art in Form), and an art-supplies store (Seattle Art, moved from Ninth Avenue to Western Avenue).

The Belltown art scene was predicated on the availability of big spaces at cheap rents in the heart of an urban cultural milieu. As such, it had a preordained lifespan. As with other artistic neighborhoods in New York, Chicago, and elsewhere, the artists would be gentrification's shock troops, rehabilitating the area's reputation in advance of more lucrative land uses.

The Virginia Inn, located at First Avenue and Virginia Street, opened as a bar in 1910. Six years later, as Prohibition came to Washington, it became just a café—at least officially. After Prohibition's repeal, it became a beer and wine tavern, and card room. Its building was included in the Pike Place Market Historic District; during the district's renovations, the Virginia Inn temporarily moved a half block north. In 1980, Jim Fotheringham and Patrice Demombynes bought the Virginia Inn. They added art exhibits, bistro food, and in 1982, the Northwest's first microbrew beers. Homer Spence, a musician, raconteur, and former University of Washington professor, came to the Virginia Inn as a bartender in 1981 and stayed until his 1990 death. In 1995, the inn added hard alcohol thanks to a loosening of state liquor laws. (Above, Seattle Municipal Archives, No. 31839; below, author's collection.)

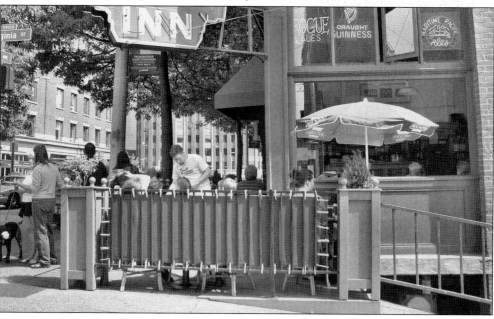

The Frontier Room on First Avenue was a quintessential dive bar for longshoremen and rockers alike. *Seattle Weekly* once described head barmaid Nina Finelli as "famously, awesomely, gruesomely rude." The front restaurant served fresh-cut fries and real ice cream shakes. Jackie Lang-Hartwig, whose family had run the place for more than 50 years, shuttered it in July 2001. The name and the neon survive on an upscale barbecue restaurant. (Author's collection.)

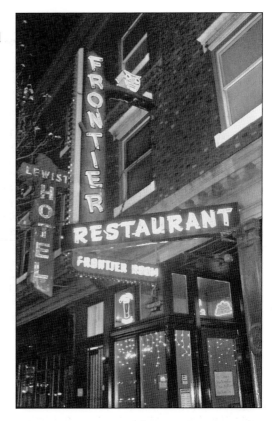

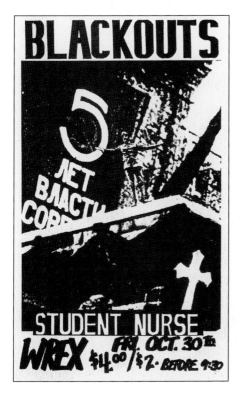

Wrex, a former leather bar on First Avenue north of Virginia Street, was Seattle's top, new wave, rock club from 1979 to 1981. In 1983, it reopened as the Vogue, offering a mix of live bands, including Nirvana's first Seattle gig, and DJ nights. The Vogue moved to Capitol Hill in 1999, surviving there until 2006; the Vain hair salon now occupies its old Belltown space. (Art Chantry collection; poster by Erich Werner from *Instant Litter*.)

The Trojan Horse, a crimson-wallpapered steak house and lounge on Fifth Avenue, became the rock club Astor Park in 1978. Its most famous show occurred in 1981 when U2's first Seattle gig was moved from the larger Showbox Theater. Astor Park closed in 1984 and was later demolished. Seen behind it is the 1962-built Sixth and Lenora Building, one of Belltown's first modern office buildings. (UWSC, Hamilton 23-18.)

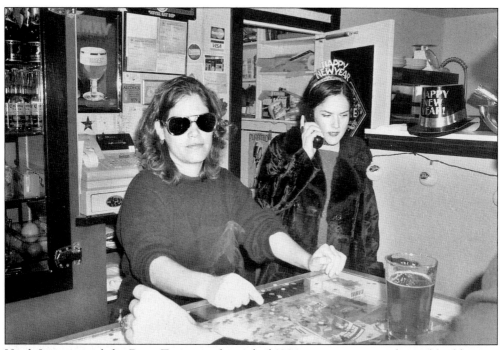

Hank Ivan opened the Ditto Tavern at the end of 1984 in a one-story industrial building on Fifth Avenue near Bell Street. Future members of Soundgarden, Mudhoney, and Mother Love Bone played early gigs there. The place had several successive owners and concepts until its 2001 demolition. (Author's collection.)

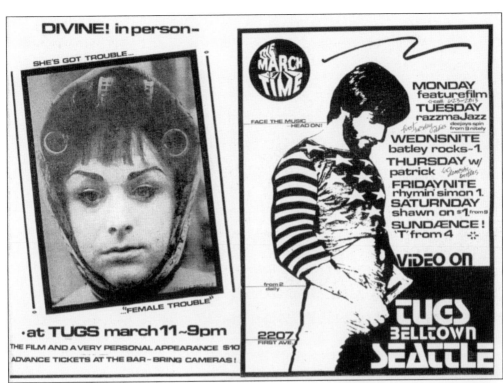

DIVINE! in person–

SHE'S GOT TROUBLE...

"FEMALE TROUBLE"

• at TUGS march 11~9pm
THE FILM AND A VERY PERSONAL APPEARANCE $10
ADVANCE TICKETS AT THE BAR - BRING CAMERAS!

THE MARCH OF TIME

FACE THE MUSIC
HEAD ON!

MONDAY
featurefilm
TUESDAY
razzmaJazz
deejays spin
from 9 nitely
WEDNSNITE
batley rocks~1.
THURSDAY w/
patrick
FRIDAYNITE
rhymin' simon 1.
SATURNDAY
shawn on $1 from 9
SUNDÆNCE !
'T' from 4

VIDEO ON

from 2
daily

2207
FIRST AVE.

TUGS BELLTOWN SEATTLE

Tugs Belltown (1979–1989) on First Avenue was a gay bar that welcomed friendly straights to the dance and mayhem. It had a punk/new wave dance night hosted by Norman Batley (later a DJ on KNDD-FM). Suburban young adults would go to Tugs for new wave night, and then get their minds blown away when they came back on a regular gay night. (Seattle Public Library collection; from *Seattle Gay News*.)

In 1984, an artists' housing collective, the Subterranean Cooperative of Urban Dreamers (SCUD), leased the Sound View Apartments on Western Avenue south of Wall Street. Until its demolition 12 years later, the building became famous for Diane Sukovathy's wall of Jell-O molds and for the Free Mars (later Cyclops) restaurant on its ground floor. A new Cyclops operates nearby at First Avenue and Wall Street. (Cam Garrett.)

Attorney Stephanie Dorgan (future wife of R.E.M. guitarist Peter Buck) and her partners opened the Crocodile Café in April 1991 at Second Avenue and Blanchard Street just in time for the Seattle rock scene to become world famous. (The former Athens Café building had been vacant for a decade.) Thousands of acts have appeared there, ranging from national cult favorites, to local superstars. It has also hosted art exhibits, political fund-raisers, and monthly "I Heart Rummage" urban craft fairs. And it is one nightspot that looks good in the light of day, serving up hearty meals and weekend-morning brunches. (Author's collection.)

And The Weathered Wall, The Purity Remains, usually called just The Weathered Wall, operated from 1992 to 1996. The three-level establishment on Fifth Avenue near Virginia Street offered an eclectic mix of live bands, DJs, poetry slams, and performance art. A successor venture, I-Spy/Nation, took over the space with similar bookings until 2002. (Author's collection.)

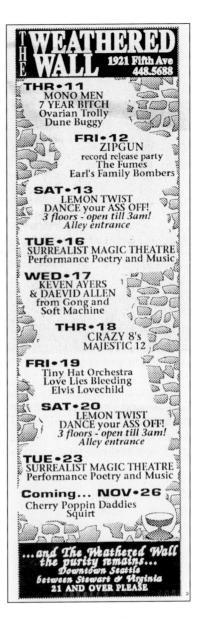

THE WEATHERED WALL 1921 Fifth Ave 448.5688

THR•11
MONO MEN
7 YEAR BITCH
Ovarian Trolly
Dune Buggy

FRI•12
ZIPGUN
record release party
The Fumes
Earl's Family Bombers

SAT•13
LEMON TWIST
DANCE your ASS OFF!
3 floors - open till 3am!
Alley entrance

TUE•16
SURREALIST MAGIC THEATRE
Performance Poetry and Music

WED•17
KEVEN AYERS
& DAEVID ALLEN
from Gong and
Soft Machine

THR•18
CRAZY 8's
MAJESTIC 12

FRI•19
Tiny Hat Orchestra
Love Lies Bleeding
Elvis Lovechild

SAT•20
LEMON TWIST
DANCE your ASS OFF!
3 floors - open till 3am!
Alley entrance

TUE•23
SURREALIST MAGIC THEATRE
Performance Poetry and Music

Coming... NOV•26
Cherry Poppin Daddies
Squirt

...and The Weathered Wall
the purity remains...
Downtown Seattle
between Stewart & Virginia
21 AND OVER PLEASE

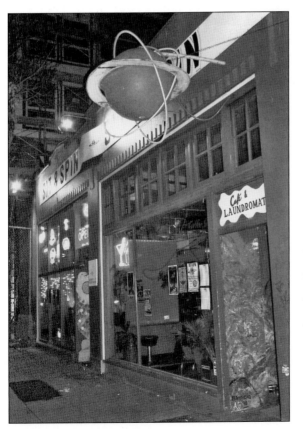

Lisa Bonney and Michael Rose started Sit and Spin in 1993 in a Fourth Avenue building that had previously been the William Traver art gallery and Vic Myers's jazz club. The business combined a restaurant, bar, live-music space, art gallery, and coin-operated laundry. It also had classic children's board games on its walls. The place lasted a decade; the Spitfire sports bar is there now. (Author's collection.)

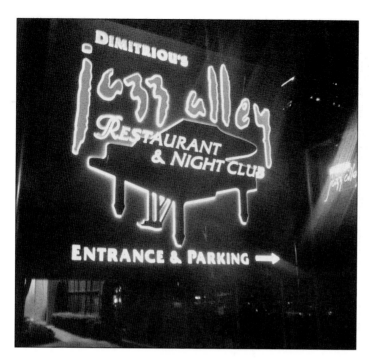

Dimitriou's Jazz Alley opened in the University District in 1979. Six years later, it moved to the ground floor of the United Airlines (now Active Voice) Building at Sixth Avenue and Lenora Street. In 2002, *DownBeat* magazine named it one of the top 100 jazz clubs in the world. Artists who have performed there include Oscar Peterson, Nancy Wilson, Taj Mahal, Eartha Kitt, Diane Schuur, McCoy Tyner, Ray Brown, and Dr. John. (Author's collection.)

In 1995, Elliott "Mack" Waldron opened Tula's jazz club two doors north and a world away from the Crocodile Café on Second Avenue. The *Seattle Times*'s Tom Scanlon described it as "unpretentious . . . cozy and decidedly glam-free, a relaxing, sophisticated oasis from all the low-brow, deliriously mindless nightlife swarming in the blocks around it." The space had previously been Soho, a rock club by night and a fashion boutique by day. (Author's collection.)

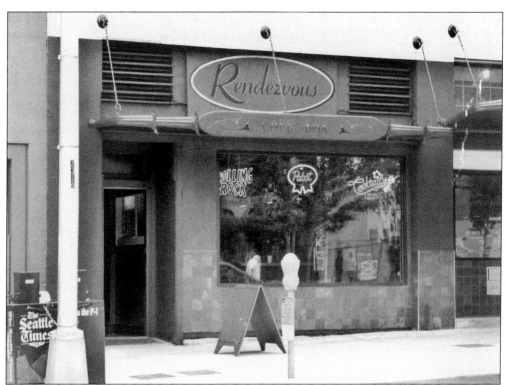

The Rendezvous restaurant and its Jewel Box Theater room were in slow decline when Jerry Everard, Jane Kaplan, Tia Matthies, and Steve Freeborn bought it in 2002. They changed the bar's decor from sleazy to snazzy and added a "grotto" section in a former basement speakeasy room. The Jewel Box now hosts live bands, film screenings, fringe theater productions, and neo-burlesque shows. (Author's collection.)

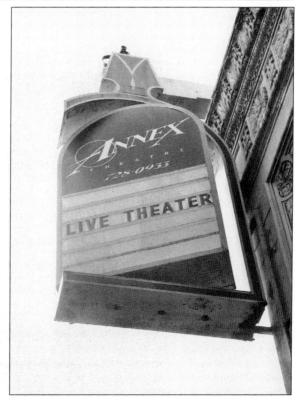

Annex Theater opened in 1986 in a former dance studio on Fourth Avenue. The fringe troupe's mission statement vowed to produce original dramas and comedies in "an environment of improbability, resourcefulness, and risk." It became best known for *Spin the Bottle*, a monthly cabaret billed as incorporating "music, dance, comedy and whatever else anyone comes up with." In 1999, it gave up its own space, opting to use rental halls. (Author's collection.)

The Annex Theater's former space was acquired by the nonprofit Vera Project, which bills itself as "a music and arts center run by and for youth." It moved there from the IBEW Hall, as seen in this image. When the ex-Annex building was razed in 2005, Vera's all-ages concerts and arts-education programs moved to the Seattle Center. The old site will become the 32-story Escala condominium tower in 2008, featuring homes priced up to $10 million. (Author's collection.)

Teatro ZinZanni, a European-inspired cabaret/dinner theater in a mirror-encrusted show tent, opened in 1998 in lower Queen Anne district. In 2002, it opened swankier digs on the former Cadillac dealer lot at Sixth Avenue and Battery Street. In August 2007, it moved back to its prior spot when its Belltown block became slated for a 37-story condominium tower. (Author's collection.)

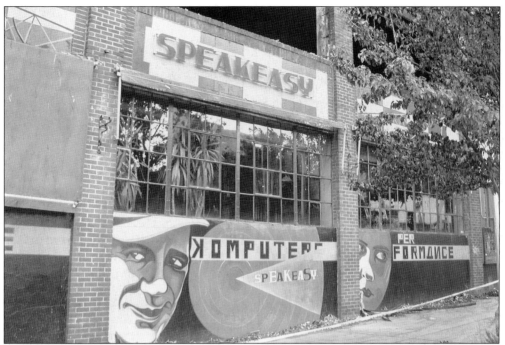

Brothers Michael and Tyler Apgar, and Michael's wife Gretchen, opened Seattle's first Internet café in June 1995. The Speakeasy Café was a vast yet comfortable room serving coffee, pastries, sandwiches, beer, and wine. Users signed up at the counter for access to one of a bank of computer terminals. A backroom performance space hosted musical and theatrical shows. Its owners soon expanded with Speakeasy.net, offering e-mail accounts and home Internet access. The café burned in an electrical fire on the night of May 18, 2001. The building was razed five years later. Speakeasy.net's offices had already moved a block away before the fire; the company's since been sold to Best Buy. (Author's collection.)

The 211 Club, Seattle's serious pool hall, was named for its original address on Union Street. It was the main setting for David Mamet's film *House of Games*. It moved in 1987 to Belltown in the building where the Speakeasy Café later opened. Rising rents forced the 211 Club's closure in December 2000, saving its vintage pool tables from the fire that engulfed the building five months later. (Author's collection.)

Myke McAlpin opened Mama's Mexican Kitchen, named for his grandmother, on Second Avenue and Bell Street in 1974. It quickly became known for hearty, Cal-Mex-style meals at moderate prices, strong margaritas, sidewalk dining, and funky decor—particularly in the Elvis Room, stuffed with over 100 Presley posters, LP covers, clocks, umbrellas, and wall hangings. (Author's collection.)

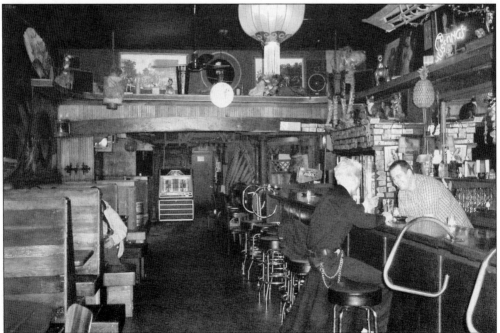

McAlpin expanded in 1995 with the tiki kitsch–themed Lava Lounge two doors south of Mama's. The space had previously housed Hawaii West, a notorious dive bar. With its custom wood booths and volcano murals, it thrived as a hangout for rockers, artists, and singles. (Author's collection.)

Patricia McGuinness Ryan bought the Two Bells Tavern (see page 54) in 1982, turning the rundown little bar into the virtual living room for the Belltown arts community. It offered art exhibits; folk and country-rock bands; spoken-word readings; and even stage plays while serving gourmet burgers, sandwiches, and microbrew beers. It has survived as a refuge for regular folk left behind by the neighborhood's gentrification. Artist-curator Rolon Bert Garner came to work as a part-time bartender for Ryan in 1982 and married her two years later. Ryan sold the Two Bells to Jeff Lee and Tina Morelli-Lee in 1999 before dying in 2001 after a seven-year bout with cancer. The Lees added cocktails and steaks but otherwise left it the same. (Author's collection.)

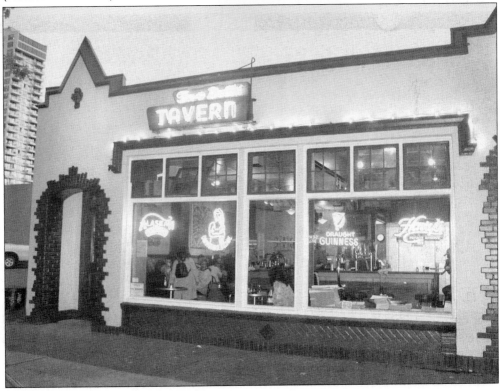

2nd Avenue Pizza was opened in March 1998 by musician/artists Jeffrey Smith, Darren Morey, and Susan Robb on the ground floor of the Commodore Hotel building. The front room served slices, pastries, and beer in a retro-modern atmosphere; the backroom hosted rock bands and movie screenings. Raine La bought it in 2003 and closed it a year later. (Author's collection.)

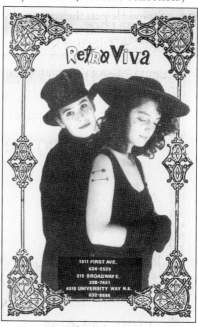

Ashleigh Talbot, a SCUD resident, illustrator, and tattoo artist, created advertisement images for two First Avenue shops, Jet City (a kitsch and knickknack store) and Retro Viva (a vintage and new wave fashion boutique). Retro Viva–owner Cindy Speare now runs the Powder Room, a young women's store at First Avenue and Stewart Street. (Elaine Bonow collection.)

The Trade Winds was the downstairs bar/restaurant in the Sailors Union of the Pacific building. It was a beautiful, dark tiki joint with a back bar decorated with exotic coins from around the world collected from sailor patrons. It later became My Suzie's Oriental Pacific, one of the last Belltown bars to offer a workingman's happy hour at 6:00 a.m. (Author's collection.)

Art collector Ben Marks started the Belltown Café in the early 1980s. It became a hangout for the painters and illustrators who gathered around the regrade's cheap rents. It was later run by homeless advocate Bob Willmott to benefit his Strand Helpers free-food program (named for the Belltown SRO hotel where it began). The café closed after a 1986 fire gutted its interior. Willmott was fatally shot in 1990 while trying to evict a man from a Strand Helpers shelter; his group still serves free lunches today. (Author's collection.)

Spike Mafford (son of prominent local artists Michael Spafford and Elizabeth Sandvig), Jan Cook, and William "Billski" Moore founded Galleria Potatohead, an artist-run exhibit space, in 1986 at First Avenue and Cedar Street. It moved to Ballard Avenue, then in 1990 to the old Film Row regional office of RKO Radio Pictures north of Second Avenue and Bell Street. The Galleria Potatohead's basement was subleased as the first practice space for an up-and-coming rock band named Pearl Jam. (Author's collection.)

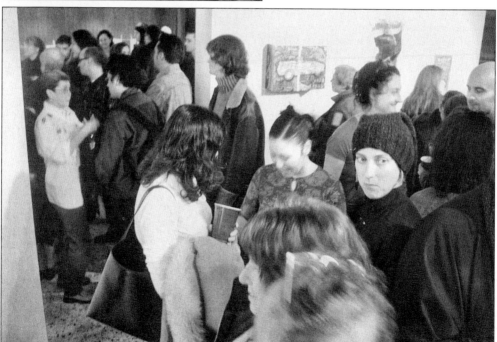

Multimedia artist Greg Lundgren cofounded Vital 5 Productions in June 1998. It was one of three temporary art spaces in a group of Second Avenue storefronts scheduled to be razed for Art Institute of Seattle student housing that fall. From there, Vital 5 moved to this former Toyota showroom on Westlake Avenue (a condo, hotel, and Whole Foods Market are there now). Lundgren now co-owns the Hideout bar on First Hill. (Author's collection.)

The former Seattle Empire Laundry, built in 1914 at 66 Bell Street, became the Alaska-Arctic Fur Company plant in 1951. In 1955, it produced 5,000 official Davy Crockett hats a day. By the 1980s, it housed artist spaces, including the Lincoln Arts Center, a black box theater space that hosted plays, all-ages rock shows, and dance classes. In 1998, it was redone into loft condominiums. (Author's collection.)

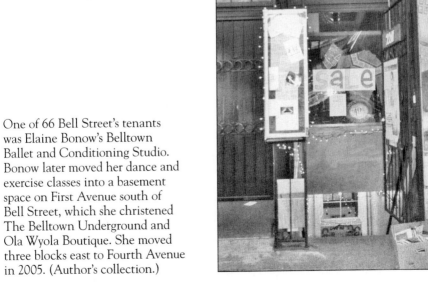

One of 66 Bell Street's tenants was Elaine Bonow's Belltown Ballet and Conditioning Studio. Bonow later moved her dance and exercise classes into a basement space on First Avenue south of Bell Street, which she christened The Belltown Underground and Ola Wyola Boutique. She moved three blocks east to Fourth Avenue in 2005. (Author's collection.)

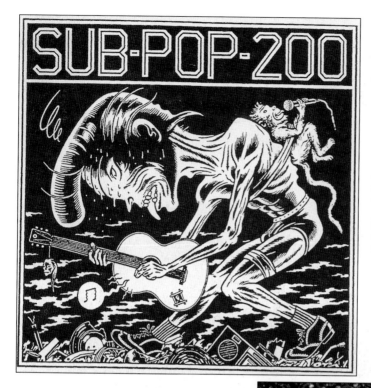

Sub Pop Records, famous in the early 1990s for introducing Nirvana, Mudhoney, and Soundgarden to the public, has been based in Belltown ever since Bruce Pavitt and Jonathan Poneman founded it in 1987. It has had three office locations over the years, starting in the Terminal Sales Building, plus two Sub Pop Mega Mart retail sites. (Author's collection.)

Textile artist and clothing designer Darbury Stenderu opened her own shop on First Avenue in 1990. She sold sensual, one-of-a-kind gowns, shirts, jackets, accessories, pillows, and bedspreads. She has also designed costumes for rock stars, including Sky Cries Mary singer Anisa Romero (seen here), ballet companies, and feature films. Stenderu, the longtime girlfriend of ex-Nirvana bassist Krist Novoselic, gave up the storefront in 2005 but still sells her works through other outlets and online, where she promises, "Each one original and imperfect." (Author's collection.)

In 1962, restaurateur-raconteur Ivar Haglund (1905–1985) took over sponsorship of Green Lake's Fourth of July fireworks show. In 1965, he moved his Fourth of Jul-Ivar's to Elliott Bay. In 1989, it became an all-day event at Myrtle Edwards Park north of Pier 70 with live music and beer gardens. The afternoon attractions ended in 2005, but the pyrotechnics go on. (Author's collection.)

In 1982, led by city council member George Benson, Seattle brought two surplus Australian streetcars into service on existing rails along the waterfront. The Waterfront Trolley's route eventually extended from Pier 70 south to the Chinatown-International District, serving 400,000 riders per year. Despite its popularity, it ceased operations in 2005 when the Olympic Sculpture Park (see page 126) took over the trolley's garage site. (Author's collection.)

The Apex Belltown Cooperative opened in 1984 after more than two years of fund-raising and remodeling by its founding members. The result was 21 affordable-housing units with shared bathrooms and kitchens in a former SRO hotel on First Avenue near Bell Street. The mural on the building's north side, promoting a 1992 neighborhood festival, will be hidden by a new condominium building by 2008. (Author's collection.)

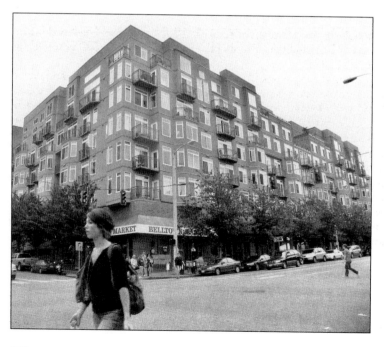

The Belltown Court was built in 1992–1993 on the former Film Exchange Building site at First Avenue and Battery Street. It exemplifies a mixed-use building type that sprung up under 1990s Seattle building codes—five or six wood-frame residential floors above a concrete main floor of retail spaces with parking underground. Built as apartments, the building has since been converted to condominiums. (Author's collection.)

Seven

BELLTOWN TODAY

The residential population of Belltown fell to approximately 5,000 by 1970 and declined further after many SRO hotels closed. The number of residents tops out at over 11,000 now with an average household income of $62,123.

After the Vogue proved straight people would indeed come to Belltown to drink and dance, larger, more mainstream nightclubs emerged. Among the first, both on First Avenue, were Casa U Betcha (opened in 1989) and Downunder (opened in 1991). Both places began on a simple premise: create an exciting yet comfortable place for image-conscious young women and the fellows would follow in tow or in search. Both places, and the mega-clubs that opened later, were the sites of raucous partying scenes right up to the 2:00 a.m. closing time; Downunder often stayed open without booze as late as 4:00 a.m.

First Avenue was still sparsely populated when the clubs first emerged. Those who did live on First, the artists and the low-income seniors, had little political clout to complain about the lines and the shouting and the fighting that would occur outside the clubs.

The new residential towers heavily advertised their proximity to exciting nightlife. Some of their new occupants, however, wouldn't care for everything they saw and heard.

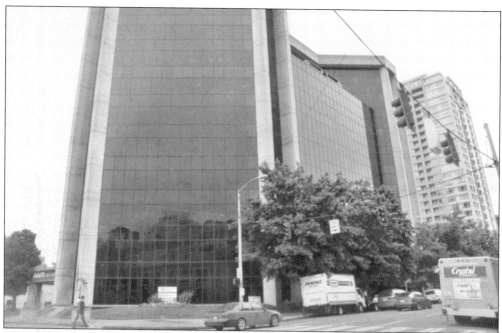

Martin Selig, born in 1936, began his career as a real estate developer with a Kmart strip mall in Bellevue. At his peak in the 1980s, Selig controlled one third of Seattle's office space before his aggressive tactics left him financially overextended and he had to sell assets. But he has held on to his Fourth Avenue and Battery Street (seen here), and Fourth Avenue and Blanchard Street buildings, two sprawling high-rise office projects dressed in basic black. When they were built in 1977 and 1979, respectively, they were risky investments in a stretch of town some considered underdeveloped and in a regional economy still mired in a long-term recession. (Above, *Belltown Messenger*; below, author's collection.)

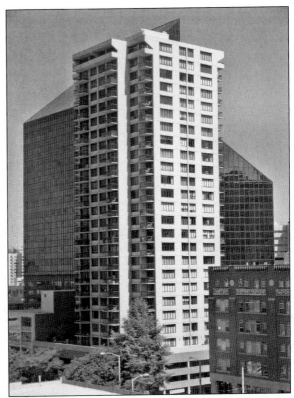

Belltown's office towers were projects of a type downtown Seattle already had. But the big buildings for which Belltown ultimately became known were condominiums and luxury apartments. Among the first high-rise condominium towers in the area were the 26-story Royal Crest, built in 1974 at Third Avenue and Lenora Street (seen here with Selig's Fourth Avenue and Blanchard Street building behind it), and the 27-story Grandview, built in 1977, at Third Avenue and Blanchard Street. (Both author's collection.)

The 18-story Harbour Heights was built in 1980 at Second Avenue and Cedar Street. After these first pioneering projects, there weren't many more for several years. The more recent boom started with Arbor Place (seen here), built in 1988 at Second Avenue and Vine Street. Like several of the buildings constructed at the time, Arbor Place opened with rentals before being converted to condominiums. After this, residential construction kept increasing and hasn't slowed down since. (Author's collection.)

Western Avenue, in particular, has become a condominium canyon since the early 1990s with mid-rise and high-rise buildings stretching almost continuously between Battery and Broad Streets, and more going up in seeming every remaining underdeveloped plot. (Author's collection.)

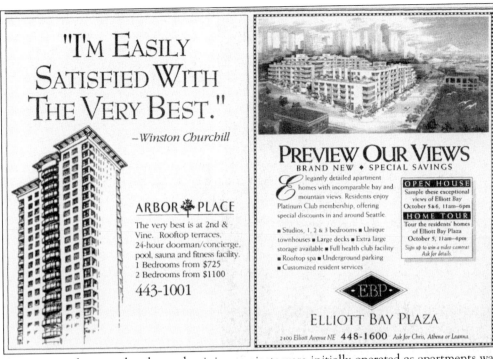

One reason why several early condominium projects were initially operated as apartments was that, around the area, home ownership traditionally meant detached single-family dwellings. Condominium and luxury-apartment marketers had to persuade people to invest in homes lacking basements and backyards and white picket fences. They created advertisements promising "the good life," urban style— luxury, convenience, views—and a wealth of cultural experiences right outside one's door. Above is an example of typical advertising of this type from 1992 when the concept was still relatively new. Below, a sidewalk-level billboard promotes the yet-unfinished Cristalla Building. (Both author's collection.)

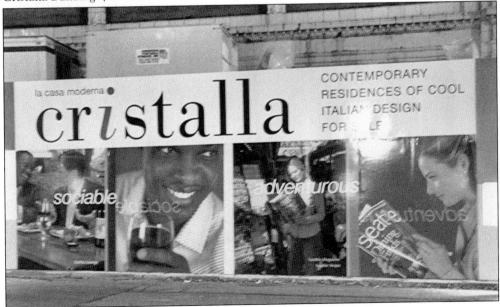

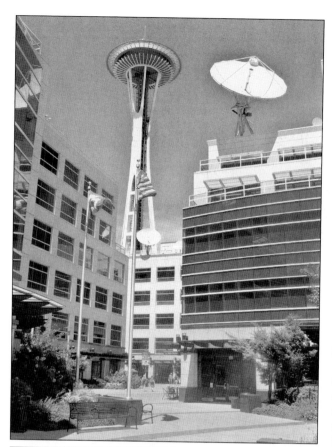

The Fisher family replaced its KOMO Radio-TV Building with the 300,000-square-foot Fisher Plaza. Opened in stages starting in 2000, it combines modern, high-definition television studios with offices, retail spaces, restaurants, and high-bandwidth Internet hubs. (Author's collection.)

Martin Selig's eight-story Western Building, designed as two contiguous semicircles near Western Avenue and Denny Way, formerly housed the world headquarters of Airborne Express, an air-express and delivery company acquired in 2003 by German-based DHL. Current tenants include biotech company Dendreon, social networking Web site Jobster, and a digital-content storage firm. (Author's collection.)

When the American Can Company moved out of its waterfront plant (see page 63) in 1976, wholesale apparel showrooms moved in. Today it is the headquarters of RealNetworks, supplying Internet audio-video content and software. The Art Institute of Seattle's culinary school also occupies part of the building. (Author's collection.)

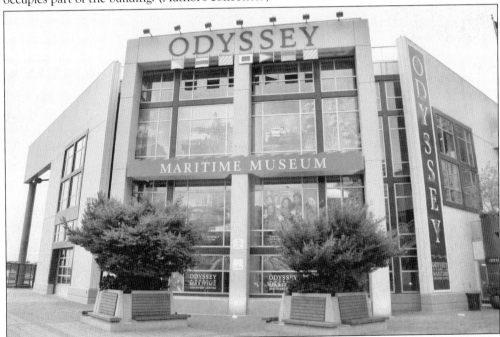

The Odyssey Maritime Discovery Center opened at the Bell Street Pier in 1998. Billing itself as "the nation's only contemporary, interactive maritime museum," it offers over 40 exhibits relating to sea travel's past and present on the personal, commercial, and military levels plus seminars, public forums, displays, and an annual career fair. (Author's collection.)

Regrade Park first opened in 1976 in a former vacant lot at Third Avenue and Bell Street. In 2004, the city remade it as a dog park, an officially sanctioned off-leash area. Chain-link fencing keeps the canines in and, critics claim, encourages "less than upscale" humans to stay out. (Author's collection.)

The Belltown P-Patch opened at Elliott Avenue and Vine Street in 1995 after six years of community lobbying and volunteer construction. The working park includes 40 garden plots for public use surrounded by landscaped paths and metal sculptures. The property incorporates the Belltown Cottages, three survivors of what had been an 11-home bungalow court built in 1916. One of the cottages houses a writer in residence, chosen each year by the Richard Hugo House literary arts center. (Author's collection.)

The Delaware-born Tom Douglas came to Seattle in 1978. After serving an assortment of odd jobs, he went to work at Café Sport in the Pike Place Market. In 1989, Douglas and his wife, Jackie Cross, opened the Dahlia Lounge at Fourth Avenue and Virginia Street with this squirming-fish neon sign. Douglas helped invent and promote Pacific Rim cuisine, combining fresh local ingredients with styles and methods inspired by Asia, Alaska, California, and Canada. Douglas and Scott have since added four nearby restaurant/bars (Palace Kitchen, Lola, Etta's Seafood, Serious Pie), a retail bakery, a rental ballroom, a catering operation, the kitchen in the Teatro ZinZanni dinner theater, a line of bottled sauces, and a series of cookbooks. Douglas also regularly appears on radio and television shows locally and nationally. (Right, Ronald Holden; below, author's collection.)

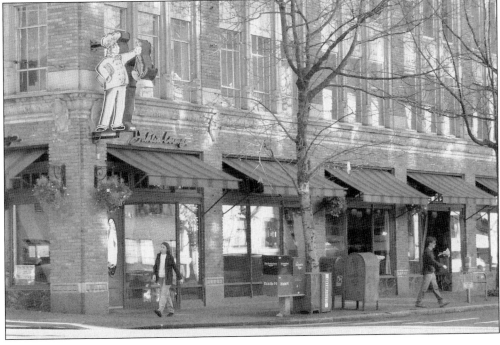

The upscale Queen City Grill opened in July 1987 at the former First Avenue and Blanchard Street site of the downscale Queen City Tavern. Chef Alan Davis devised a simple, classy menu built around fish, steaks, and chops. The mahogany bar became a popular trawling ground for single professionals. (Author's collection.)

Christine Keff opened Flying Fish in 1995 in a former First Avenue and Battery Street printing plant. The restaurant is known for seafood specialties and pan-Asian entrees. "When we first opened in 1995," Keff has written, "no one here had heard of mong chong, opaka paka, monkfish liver or cod cheeks. Now some of those items are commonplace on menus around the city." Keff's operation helps support organic, sustainable agriculture in Washington State. (Author's collection.)

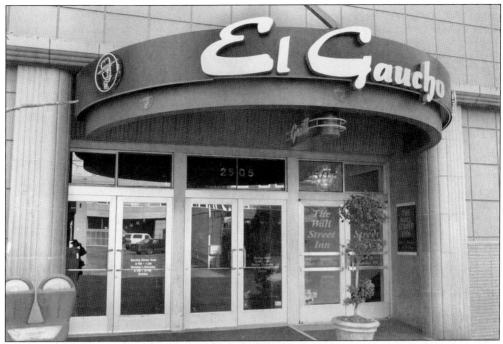

In 1996, the Sailors Union of the Pacific building became El Gaucho, owned by Paul Mackay and inspired by an Olive Way eatery that had closed in the 1980s. *Playboy* magazine named the new Gaucho "one of the top 12 steak houses in the nation." State anti-smoking laws have made Mackay close his cigar bar, but El Gaucho's restaurant, bar, piano lounge, retro-swank intimate hotel, and big-picture movie theater are still going strong. (Author's collection.)

The loosening of Washington State's liquor laws in the 1990s brought an explosion of bars and nightclubs. They ranged from intimate bar/bistros and wine salons, to expansive dance halls, complete with valet parking and dress codes. The Bada Lounge, open between 2001 and 2004 on First Avenue, was in between those extremes. It was a large, upscale/casual bar with retro-modern decor and DJs. (Author's collection.)

Some mega-nightclub patrons regularly arrived en masse via commercial party buses. Belltown overtook Pioneer Square as Seattle's busiest, noisiest place to be on a weekend night. Some condominium residents took umbrage at all the noise and rowdy behavior; they lobbied the city to regulate nightspots and to shut down troublesome ones. (Author's collection.)

As the working-stiff taverns either closed, upgraded, or remarketed themselves to the youth market, Kelly's at Third Avenue and Bell Street became Belltown's last un-hippified dive bar. Ex-grunge rockers and young stoners aren't here, just the elderly and the veterans of hard lives. It still only serves beer and wine. It closes no later than 11:00 p.m. most nights; most of its clientele doesn't stay up beyond that hour anymore. (Author's collection.)

The Glaser Building at First Avenue and Wall Street, built in 1909 as the New Latona Hotel, now hosts the new Cyclops restaurant/bar and the Euro-modern-style Ace Hotel. The Glaser family used to own local bottling rights to Pepsi and 7UP, hence the dual faded signs on the building's side. (Author's collection.)

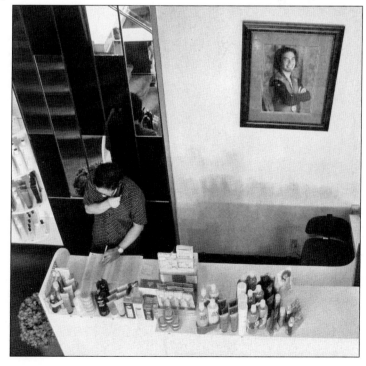

Yuki Ohno came here from Tokyo in the 1970s via London. In 1980, he opened Yuki's Diffusion hair salon on Fourth Avenue south of Bell Street. At the time, his salon and the William Traver Gallery (now on Union Street) were the only retail businesses along that stretch of Fourth. Ohno is still there today—except when he is on the road rooting for his son, Olympic skating champion Apolo Anton Ohno (seen in the portrait on the wall). (Author's collection.)

The Zebraclub clothing store opened on First Avenue and Stewart Street in December 1985 during the peak of Seattle's youth-fashion industry (which spawned such brands as Britannia, Generra, Unionbay, and International News). Founders Michael Alesko and Bryan Johnson had been design-firm executives when they devised their "environmental retail" concept. Now with four stores, Zebraclub has outlasted the various fads that passed through its shelves. (Author's collection.)

Flint, Michigan–born Martha Manwaring ran a clothing boutique called Pin Down Girl on Second Avenue near Bell Street in the mid-1990s when she chose to sell dogs and suds instead of togs and duds. She transformed the space into Shorty's Coney Island, a combination hot dog stand, bar, and pinball/video game arcade. It hosts annual men's and women's pinball tournaments. (Author's collection.)

Louie Raffloer, ex-husband of artist Ashleigh Talbot, started Black Dog Forge in 1991 in the back of Galleria Potatohead. Fellow metal sculptors Mary Giola, Kelly Gilliam, and Dan Schwarz have since joined him. The four metalsmiths use traditional tools and techniques to create custom iron decor for homes and gardens. (Author's collection.)

From 1996 to 2004, the alley space next door to Black Dog Forge hosted Dead Baby Bikes, a bicycle repair/customization shop, which spawned a biker club of the same name. The club is infamous for its annual downhill races through the streets of Seattle, followed by raucous after-parties. The club is now based in West Seattle; the shop became Counterbalance Cycles on Queen Anne Hill. (Author's collection.)

Seafair began in 1950 when a civic-boosters' group revived the old Potlatch festival with a new theme to honor Seattle's aquatic heritage. It has since become a countywide, summer-long package of events, ranging from the Lake Washington hydroplane races, to neighborhood parades and ethnic cultural fairs. Its keynote event, the annual Torchlight Parade, travels south through Belltown toward the downtown retail district, attracting tens of thousands of spectators. In the image above, a colorful float and a drill team head down Second Avenue sometime in the 1960s. By the 2001 parade, shown in the image below, the parade's route had been moved to Fourth Avenue. (Above, Seattle Municipal Archives, No. 109033; below, author's collection.)

Seattle has had gay/lesbian pride parades since 1974. They were always held on Capitol Hill until June 2006 when organizers Seattle Out and Proud moved the event to downtown and Belltown in order to give it a higher, mainstream profile. The relocated parade took the same Fourth Avenue route as August's Seafair parade, only heading north instead of south. In 2007, parades were held at both the new and old locations. Annual pride-parade attractions include Dykes On Bikes, Queers With Corgis, drag performers, women's martial-arts teams, political-activist groups, corporate-sponsored floats, and pro-diversity church groups. (Both author's collection.)

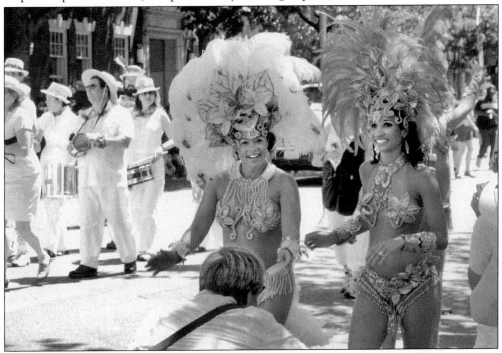

The YWCA of Greater Seattle built Opportunity Place in 2001 at Third Avenue and Lenora Street. The seven-story structure includes five stories of low-income housing, employment services, and Angeline's, a drop-in center for poor and homeless women. The lot had previously housed a Children's Hospital Thrift Store, a major shopping destination for Belltown's low-income residents. (Author's collection.)

Chef/entrepreneur David Lee founded FareStart (originally Common Meals) in 1988. It trains homeless and unemployed people for food-service careers. In 1992, it opened a teaching space and working restaurant in the Josephinum Building on Second Avenue, moving in 2007 to the former Jerseys sports bar at Seventh Avenue and Virginia Street. It serves weekday lunches and Thursday night dinners, the latter organized by guest chefs from top area restaurants. (Author's collection.)

The Millionair Club Charity has been "changing lives through jobs" since 1921. Founder Martin Johanson spelled "Millionair" without an "e," the organization says, "so that no one would feel they had to be wealthy to lend their support." Based at a former candy factory near Western Avenue and Vine Street, it dispatches workers to temporary jobs and serves 10,000 meals a month. (Author's collection.)

An unorganized, drive-up, day-labor market emerged in the 1980s along Western Avenue's sidewalks near the Millionair Club Charity, which only dispatches temporary workers from inside its building. The Hispanic advocacy group Centro de Ayuda Solidaria a los Amigos (CASA) Latina built a day workers' center where itinerant workers can take part in English-language courses and skills training. The organization plans to move to the Central District in 2009. The new location won't include street-side hiring. (Author's collection.)

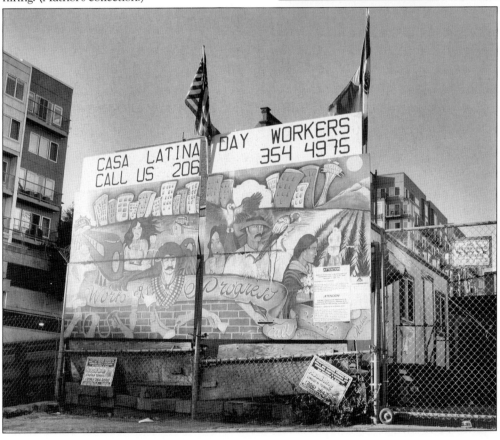

Members of the New Creation Community, which calls itself an "intentional, ecumenical community of faith," opened the Recovery Café at Second Avenue and Bell Street in 2004. The café offers meetings and drop-in services for people struggling with addictions and mental illness. The same building also houses Noel House/ Rose of Lima House, a Catholic-run women's shelter, a transitional-housing facility, and a support center. (Author's collection.)

On the afternoon of July 28, 2006, a man entered the Third Avenue and Lenora Street offices of the Jewish Federation of Greater Seattle. He stuck a pistol against a 14-year-old girl's back, forcing her to lead him through a locked lobby door into the main office. He made anti-Semitic and anti-Israeli remarks, and then began shooting. One woman died, and five women sustained serious injuries before the gunman left the building and surrendered to police. (Author's collection.)

Antioch University Seattle opened in 1975 as part of the Ohio liberal-arts college's planned nationwide expansion. The Seattle branch, at Sixth Avenue and Battery Street since 1997, targets working adults with undergraduate and graduate degree programs, and continuing education courses. Antioch Seattle survived the 2007 closure of undergraduate programs at Antioch's original campus. (Author's collection.)

The Burnley School of Professional Art, founded on Capitol Hill in 1946, became the Art Institute of Seattle in 1982 when a national chain of for-profit schools bought it. Based since 1985 at Elliott Avenue, it now serves 2,500 students in programs ranging from culinary arts and fashion design, to music production and computer animation. (Author's collection.)

Nellie Cornish started the Cornish College of the Arts in 1914. It calls itself "one of only three private, nonprofit performing and visual arts colleges in the nation." In 2003, it moved from Capitol Hill to a Denny Triangle industrial building and three nearby structures. One of these, a former Sons of Norway hall that had become a gay disco, is now Cornish's performance theatre. (Author's collection.)

Since 1991, Cliff Goodman's Seattle Glassblowing Studio on Fifth Avenue south of Bell Street has offered glass-art and bead-making classes and seminars plus facility rentals, commissioned artworks, and a large gallery specializing in brown-glass lighting and glass sinks. Live glassblowing demonstrations are offered in the studio's "hotshop" seven days a week. (Author's collection.)

Kirsten Anderson first got turned on to lowbrow contemporary art in 1996. Two years later, she founded Roq La Rue Gallery. It is now based, along with a sister gallery (BLVD, which specializes in urban contemporary and street art forms), in the former Galleria Potatohead location on Second Avenue. Other hip-art stops on Second Avenue include Suite 100, the McLeod Residence, and the designer-trinket boutiques Fancy, Schmancy, and Nancy (three separate Moore Theatre building storefronts marketed jointly as the "Second Avenue Trilogy of Awesome"). (Author's collection.)

With the Belltown housing boom have come many shops dedicated to putting good stuff in those homes. Chantreuse International on First Avenue specializes in "new mid-century modern design." That means furniture and decor inspired by nostalgia for what people in the early 1960s thought the 21st century would look like. (Author's collection.)

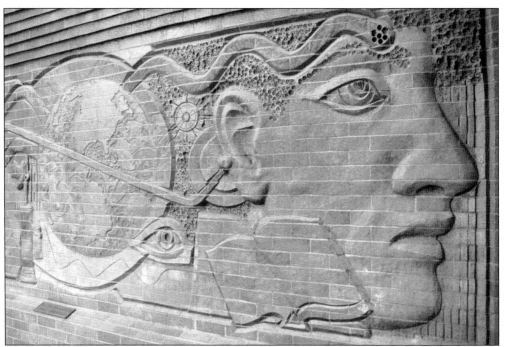

Private developers in Seattle receive zoning incentives to include public art in their projects; city- and county-funded projects must spend one percent of their building budgets on art. Above, brick relief murals decorate the otherwise blank, windowless facade of a Qwest phone switching station at Second Avenue and Lenora Street. Below, metal-relief murals decorate the street-level parking garage vents of a Western Avenue condominium building. (Both author's collection.)

The old Union Oil depot site opened as the Seattle Art Museum's Olympic Sculpture Park in January 2007 after eight years of cleanup and construction, and more than $85 million in funding (75 percent of which came from private contributions). The nine-acre park features 21 major artworks, most loaned or donated by local collectors. At right, a press tour passes Richard Serra's *Wake*; the Western Building is in the background. Below, Alexander Calder's *Eagle* was already famous from its former residence in Fort Worth, Texas. (Both author's collection.)

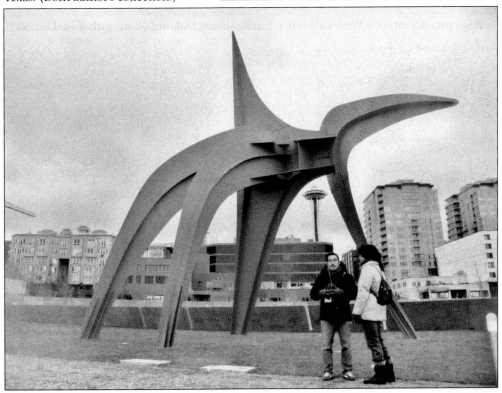

The Alexander Calder's *Eagle* sculpture may have landed here, but Belltown's official metallic bird is still the crane of the construction variety, as seen in this 2001 shot. In the mid-2000s, one of the few factors that held back the pace of condominium building was a shortage of cranes and other major construction equipment. The housing market slump that hit nationally in mid-2007 has thus far skipped Seattle, where building and buying are still going strong—especially in Belltown. (Seattle Municipal Archives.)

CLOSING REMARKS

Even as this book was in preparation, more big changes were afoot for Belltown and the vicinity. Some area condominium residents have organized to seek regulations and restrictions on large nightclubs. This isn't just a case of not-in-my-backyard naysayers harping about noise and inconvenience. In early July 2007, there was an early–Sunday morning argument in a Western Avenue parking lot adjacent to the Tabella dance club. An innocent bystander was injured. The club denied it had anything to do with the shooter. Mayor Greg Nickels called for the club's liquor license to be revoked; the state liquor board did not do so, citing insufficient evidence.

The Clise family announced in July 2007 it would put most of its Denny Triangle land holdings (15 tracts totaling 12 acres) for sale, perhaps to one huge buyer/developer. The Clises are keeping their major buildings in the area and the land beneath them. But everything they have got that is occupied by parking lots or one- or two-story buildings is up for grabs. A *Post-Intelligencer* story estimated the sale could raise as much as $200 million.

At this same time, Seattle's city government announced it was considering historic landmark status for some 37 buildings in greater downtown, of which 20 are located in Belltown and the Denny Triangle. They include the sites of the Two Bells, Roq La Rue Gallery, El Gaucho, the Ace Hotel, and the Labor Temple. It may take two or three years before any of these designations become official, and some landowners are expected to challenge them.

In a place where even the topography is malleable, the only constant is change.

ACROSS AMERICA, PEOPLE ARE DISCOVERING SOMETHING WONDERFUL. *THEIR HERITAGE.*

Arcadia Publishing is the leading local history publisher in the United States. With more than 4,000 titles in print and hundreds of new titles released every year, Arcadia has extensive specialized experience chronicling the history of communities and celebrating America's hidden stories, bringing to life the people, places, and events from the past. To discover the history of other communities across the nation, please visit:

www.arcadiapublishing.com

Customized search tools allow you to find regional history books about the town where you grew up, the cities where your friends and family live, the town where your parents met, or even that retirement spot you've been dreaming about.